IMAGES
of America

GRAND RAPIDS IN
STEREOGRAPHS
1860–1900

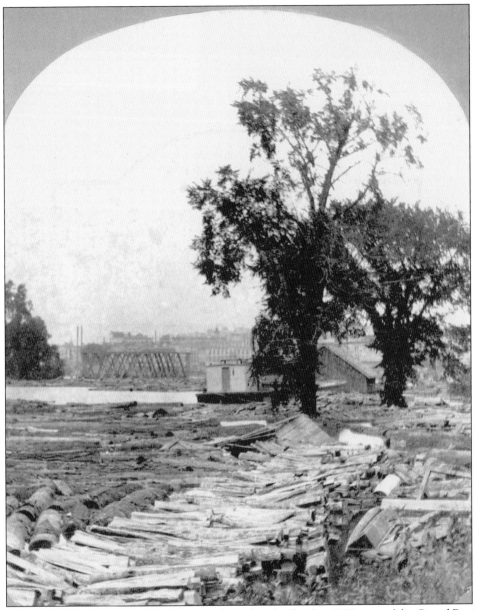

In the center distance of this view, taken just days after the flood in 1883, part of the Grand Rapids and Indiana Railroad bridge, destroyed as a logjam rushed downriver, is visible. According to the *Evening Democrat*, "It was a terrible sight to see that jam move out. The force displayed at every moment was tremendous, and the effect of the scene on the mind was one of awe and sublimity. It is but once in a lifetime that such a grand war of natural elements is witnessed." (Photograph by Barrows; courtesy of Thomas R. Dilley.)

On the cover: This is believed to be a portrait of Schuyler Colfax Baldwin, taken around 1878, when he was about 50 years of age. He is surrounded by an assortment of the many stereographic cards that he produced commercially, including those of the city of Grand Rapids. (Courtesy of the Grand Rapids Public Library.)

IMAGES
of America

GRAND RAPIDS IN STEREOGRAPHS
1860–1900

Thomas R. Dilley
Foreword by John H. Logie

ARCADIA
PUBLISHING

Published by Arcadia Publishing
Charleston SC, Chicago IL, Portsmouth NH, San Francisco CA

Printed in the United States of America

Library of Congress Catalog Card Number: 2006939088

For all general information contact Arcadia Publishing at:
Telephone 843-853-2070
Fax 843-853-0044
E-mail sales@arcadiapublishing.com
For customer service and orders:
Toll-Free 1-888-313-2665

Visit us on the Internet at www.arcadiapublishing.com

CONTENTS

ACKNOWLEDGMENTS

Like all projects of local history, this book was born of a long-standing interest in the history of my hometown, an interest that has been steadily encouraged in me by others. From the very beginning, my parents and members of my family have shared their recollections, and many friends have offered encouragement and moral support for this project. Christine Byron and Tom Wilson, my friends and colleagues in local history, have been of invaluable assistance. My friends Chuck Schoenknecht and Ward Paul have freely given me advice on antiquities, and Milton Ehlert, himself a local historian and contributor to *The Story of Grand Rapids*, edited by Z. Z. Lydens, has been unflagging in his help and support. The staff members of the local history section of the Grand Rapids Public Library, particularly Ruth Van Stee and Karolee Hazelwood, have been and remain helpful, unfailing beacons in the research process. In partial recompense for this assistance, all my royalties from the sale of this book will benefit the Grand Rapids History and Special Collections Division of the Grand Rapids Public Library.

Many sources of information have been used in the preparation of this book, including the research completed for my previous works, *Grand Rapids in Vintage Postcards: 1890–1940* and *Grand Rapids: Community and Industry,* and the sources listed in the bibliography. Many materials, in addition to many stereographs, may also be found in the beautifully preserved and scrupulously maintained collections of the Grand Rapids Public Library.

The assistance of others, however great, pales when compared with the patience, cooperation, and support unhesitatingly given to me by my wife, Debra, my daughter, Sarah, and my basset hound, Ruthie. Without them, ideas would wither and fail and words would never flow.

FOREWORD

The discovery and enjoyment of the history of Grand Rapids, my family's home town since 1865, has been a pleasure and adventure for me for many years. Whether from the many published works, from pictures and newspapers, or from the many conversations with the Grand Rapidians I have come to know, I have learned many things about the beginnings of our city and what has come before. Although the face of our city has changed greatly in the 180 years since its founding, much of its early history, and the stories of those who made it what it is today, have been preserved for all of us in the hands of collectors, both public and private, and especially in the superb collections of the Grand Rapids Public Library. Even a casual study of these marvelous materials provides a fascinating and exciting glimpse backward, giving us all a better understanding of where we truly are today. It has been this knowledge and understanding of the grand history of our city that has inspired and supported my involvement over the years in the founding of the Heritage Hill Historic District, and later, in my service as the mayor of Grand Rapids.

The photographs contained in this book are particularly interesting, because they provide not only an opportunity to see the city in the opening decades of its existence, but they do so through the eyes, and cameras, of its earliest photographers, at a time when the photographic art was as new as the city itself. Here we cannot help but see the confidence and determination of its earliest residents and entrepreneurs to establish the city and make it prosper when a half hour's walk could take one from one city boundary to another. In all of these pictures, the hopes and dreams of our great grandparents are evident as they are being realized, as are their gentle expectations that we, as the stewards of the past, as well as our own futures, will carry on the very grand work, which they began nearly two centuries ago.

Tom Dilley's enthusiasm for his subject is evident throughout these pages. For everyone who loves this city, Tom has given us a wonderful, splendidly assembled and arranged gift. Enjoy!

John H. Logie
Mayor of Grand Rapids, 1991–2003

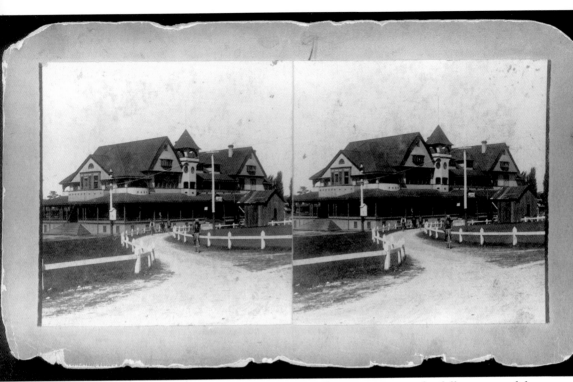

This is a view of the North Park Pavilion, presented as it appears on the full stereo card from about 1880, when it was a very popular leisure destination. The pavilion was located on the east bank of the river north of downtown. This card demonstrates the general format of all the stereographic images in this book, with two nearly identical images mounted side by side on a stiff, convex card. The ragged edges of this card illustrate the wear suffered by most antique stereo cards, the result of their being repeatedly inserted into a handheld viewer in order to allow the three-dimensional aspect of the view to be observed. (Photograph by Walter; courtesy of Thomas R. Dilley.)

INTRODUCTION

The study of stereographs of the city of Grand Rapids presents the opportunity to view the antique images from several points of interest. First, and probably most obvious, is the consideration of the images as the product of the very early, fledgling art and science of photography. Produced in the first decades after the initial invention of the process in 1839, all these images are the work of very early, often itinerant, and sometimes unknown photographers, trained in apprenticeships and making use of equipment that was bulky, complicated, and quite expensive. Although occasionally of disappointing quality, most stereographs show us the amazing and undeniable art and expertise of these early photographers, achieved as the product of their irrepressible efforts to satisfy a new and growing public demand for keepsake images of hometowns and distant travel destinations, a need that decades later was further filled, both technologically and artistically, by the picture postcard.

Just as obvious in the study of these images is their vast importance in the actual and reliable documentation of the physical appearance of the city of Grand Rapids at a time when less than 50 years had passed since it had been hewn from untamed wilderness by fur trader Louis Campau and others. Here, in these images of early buildings and streetscapes, we see the beginnings of the city we know today, as it grew and prospered in the last 40 years of the 19th century. We are also provided with some rare views of the lives and appearance of the increasing number of people who then called Grand Rapids home, many of whom could easily recall when homes here were log cabins and it was just a short walk from their doorsteps into the primeval forest that had covered the banks of the Grand River for millennia before.

Stereographic images, or what are more widely known as stereographs, stereoviews, or stereopticon cards, first came into existence in the early 1850s. The photographs that were made into stereoviews were not the first use made of the new and wondrous science of photography, born out of the happy intersection of the fields of chemistry and optics in 1839, but they were among the very first popular forms it was to take.

The art and science of stereophotography differs from more conventional image production. From early on, the stereo photographer made use of a special camera, with a double set of lenses and shutters, placed side by side within the box of the camera, designed to capture very similar but slightly different images simultaneously. The lenses were placed in the camera at the same level but at approximately the same distance apart laterally as are the eyes on the average human face. Thus, the two views taken simultaneously with such a camera will vary slightly in the angle and image, in the same way viewing a scene with one eye while the other is closed varies slightly from its opposite. Devices were also sold that allowed the photographer, using a single camera and lens, to slightly shift the position of his camera for a second shot, thus creating a series of images

that could, if properly executed, produce a true stereographic view. In following this somewhat cumbersome process, the stereo photographer was able to duplicate in his final process, at least to some degree, the three-dimensional quality that distinguishes human eyesight from that of many lower animals. It was also in this aspect of the process that stereographic photography found its art, its greatest function, and its wild popularity.

The most advantageous viewing of a stereo image required, from the beginning, a proper viewer, a device into which the stereographic card was inserted and then viewed through a set of lenses designed to enhance the three-dimensional effect. Initially such devices, first developed commercially in England in 1850, were large, expensive, and often cumbersome pieces of parlor furniture that could be and were acquired only by a select few, including Queen Victoria. In 1859, however, as the value and fascination of stereophotography became better known, devices in a more simple, handheld format, such as that developed by Oliver Wendell Holmes Sr., began to appear, making the viewing of stereo cards easier and very much within the reach of middle-class Americans.

From the outset, particularly after the appearance of the Holmes stereoscope, the popularity of stereoviews was enormous. By 1865, lending libraries, which allowed users to cheaply rent sets of cards for viewing, and commercial outlets involved in the production, but more often just the sale of large numbers of stereo cards, began to appear in Europe and America. It seems that nearly every parlor in America at this time, including some in surprisingly remote locations, featured a Holmes viewer and a box of stereographs, whether of places the owners had been or of places to which they dreamed of going.

Much of the actual production of stereographs for the national market was, from the beginning, dominated by a few commercial companies, such as the Keystone Company, of Philadelphia, which continued to offer very large numbers of cards for sale well into the 20th century. Seizing on the growing interest of the public in this medium, however, many smaller, more localized photographers, not necessarily engaged in stereophotography exclusively, began producing and selling stereo images in cities around the United States and actually produced the majority of the stereographic views of smaller towns and cities of the time, like Grand Rapids. As is the case with many early historical artifacts, certainty in the identification of the work of some of the earliest local photographers, including some of the most interesting stereographs of Grand Rapids, is difficult. All these views of Grand Rapids present to us images of a city that was bustling and self-assured and that would, over the following decades, continue to grow and dramatically change its appearance.

Paper photographic images were first produced in Grand Rapids, after the original appearance of daguerreotype photography in the decades before, by Ira G. Tompkins in the mid-1860s in his studio located on Canal Street (now lower Monroe Avenue). For the first time, these photographs included not only portraits of early settlers of the city but a variety of exterior views that were made for use with the stereoscope. Other local photographers, including Edward and Warren Wykes, O. W. Horton, L. V. Moulton, and James Bayne, following what appears to have been a national trend, all began producing stereographs of Grand Rapids at this time.

None of these early photographers was as active or as commercially successful, however, as was Schuyler Colfax Baldwin. Springing from a family of remarkable pedigree, including two Revolutionary War generals and a vice president of the United States, Baldwin came to Kalamazoo in late 1851 from upstate New York, where he had become familiar with the art and science of daguerreotype photography. Baldwin bought out the studio of another photographer in the small western Michigan town south of Grand Rapids and quickly developed a reputation as a skilled photographer, producing many high-quality daguerreotype portraits of clients in the Kalamazoo area. He was well known at the time for the artful high quality of his work, which included both portraits and landscapes in the daguerreotype form, and he eventually fitted out a wagon as a movable studio, which he took to many locations around western Michigan, presumably including Grand Rapids. Although he remained committed to the daguerreotype format during his entire career, Baldwin was a talented entrepreneur of the photographic art,

and it seems to have naturally followed from his success that he took an early interest in the stereographic process and quickly became the most proficient producer and seller of stereographs of Grand Rapids, Kalamazoo, and other cities in the area. Baldwin's views, which make up well over half the entire body of stereographic images of this city, include street scenes and panoramic views of the city, as well as images commissioned by proud businessmen and home owners. A lifelong bachelor, Baldwin moved to Grand Rapids late in his life as his health failed, to be with the families of his sisters and a nephew, a medical doctor who attended his death at the age of 78 in 1900. Baldwin's life and career spanned the formative years of the new science of photography, and he left behind an irreplaceable photographic record of early Grand Rapids, in the form of his several hundred stereographic images, which provide us today with many of the wonderful images presented in this book.

The tremendous public excitement and passion for stereographic images began to fade in the last part of the 1800s, as the novelty of the three-dimensional image began to cool, and other forms of visual art began to take its place. The advent of the picture postcard, which first appeared in the late 1890s, offered a cheaper means of capturing an image and also allowed the picture to be mailed. The appearance of early versions of nonprofessional cameras, together with advances in photograph processing, took away much of the mystery of the early photographic process and allowed many people to cheaply become their own photographers. Significant advances in printing and color lithography made brighter, colored images available to the public for little or no investment and further hastened the decline of stereophotography, at least in its original form. All these factors significantly reduced the mania for stereographs, although such images continued to appear as mementos of travel destinations well into the next century. The idea of stereophotography survived and on a limited basis prospered, however, long after the last true stereographs were produced in the 1930s in the popular View-Master slides and viewers that are still purchased as travel souvenirs today.

The stereograph images that appear in this book document the appearance and activity of the city between the Civil War and the end of the 19th century. The cards are rare and difficult to find, in part because of their constant use by their original owners and the wear they suffered as a result. All the images in the book are from the collections of the author and that of the Grand Rapids Public Library. An effort has been made to identify the original photographer of each image, and where known, this information is included at the end of each caption, as is the name of the present owner of the card. Thus, a card produced by Schuyler Colfax Baldwin and owned by the author will appear as (Baldwin/Dilley). The cards of the Grand Rapids Public Library are identified as GRPL.

All stereographs consist of a pair of nearly identical photographic images, mounted side by side on a stiff card for viewing. The images in this book are taken from these cards but do not duplicate the original double-image format. Because the proper three-dimensional viewing of stereographs requires a special viewing device to fully appreciate the three-dimensional effect, it has not been possible to capture and reproduce this aspect of each image. Still, the images of Grand Rapids included in these pages are well worth viewing and study for the impressions they capture of the earlier decades of the city's history.

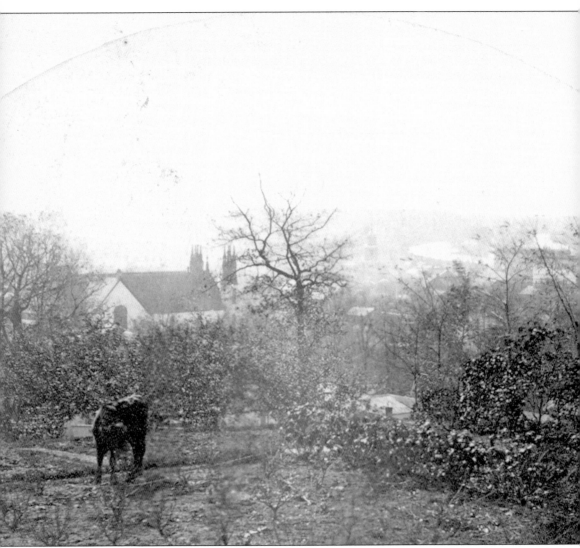

This very early stereograph of Grand Rapids was taken from the summit of the hills above and to the east of downtown, in about 1860. The only building visible in the picture is the very first view of St. Mark's Episcopal Church, on Division Avenue at Pearl Street, a little more than a decade after its original construction in 1848. The twin towers of the church were added in 1851. Little of the commercial development had occurred at this time, as is evinced by the cow grazing in the foreground. (GRPL.)

One

THE CITY FROM ABOVE

Beginning at about the same time as the opening shots of the Civil War in 1861, stereographic views of the city of Grand Rapids, then only a decade after its incorporation and 35 years after its founding by fur-trader Louis Campau in 1826, began to appear. Here, as in countless other locations, the beginnings of the "photographic art" were slow, but interest in the images increased rapidly when the public became familiar with the three-dimensional quality of the stereographs, and they happily paid the relatively modest investment required to bring these visual wonders into their homes.

Doubtlessly produced in response to local demand for these "home town" views from a growing number of local residents who owned a stereoviewer and a number of cards of distant, more exotic locations, most of these early local stereographs were produced in small numbers, by photographers such as O. W. Horton, L. V. Moulton, C. E. Walter, and of course, the prolific Schuyler Colfax Baldwin, as well as others whose identities are not always known to us. Here early views of the city are seen, taken from the heights of the hills above the eastern banks of the Grand River, as well as its main streets, which document the appearance of downtown Grand Rapids in its first half-century of existence and the growth it was already beginning to experience, at a time when the streets of the small town are still unpaved and trees abounded in areas from which they have long since been banished. Views of buildings and businesses not only show the appearance of the city, but testify to the pride and confidence of the owners, anxious to show customers and competitors that Grand Rapids was becoming a thriving commercial center. Other views of the Grand River reveal a far wilder and less developed appearance than that which came in the next 50 years, as industry and development changed its look forever. Despite the obvious changes that have come to the city in the nearly 150 years that have elapsed since these stereographic photographs were taken, sufficient remnants of that time remain today to allow the careful observer to find the way easily through the Grand Rapids of 1870.

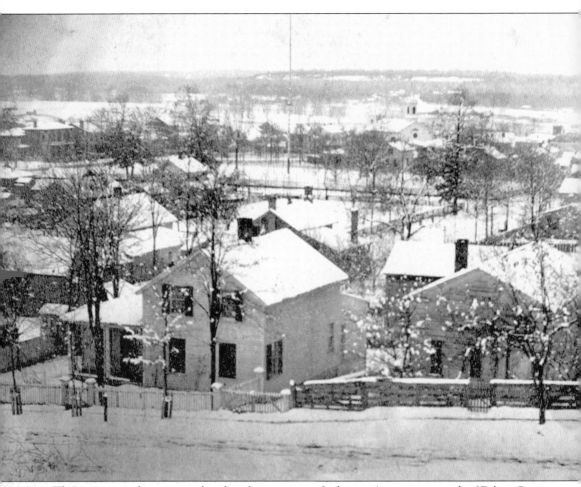

This is a very early stereograph, taken from a spot on Lafayette Avenue just north of Fulton Street in about 1866. The view looks southwest from this point, over the site of the present Masonic temple building, which would rise here in 1917. In the 1860s, this part of the city, which in the following decades became entirely commercial, was obviously entirely residential. (GRPL.)

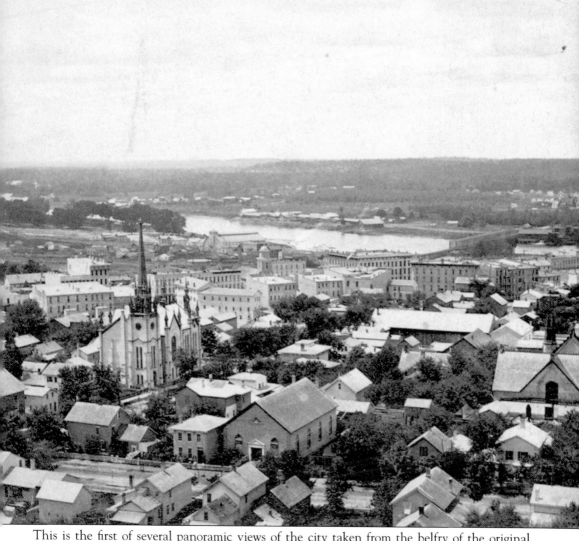

This is the first of several panoramic views of the city taken from the belfry of the original Central High School, at the summit of the hill above the city to the east, beginning in about 1870. The church at the center left is the First United Methodist Church, at the corner of Fountain Street and Division Avenue, built in 1869 and razed in 1917 for the present Keeler Building. The back of St. Mark's Episcopal Church is visible at the right side of the photograph, as is one of its twin towers. (GRPL.)

This is a similar panorama, but looking more to the south, that was taken in about 1875, a few years after the construction of the Fountain Street Baptist Church in 1873. The block at the center of the photograph is the new Morton House Hotel, built after its predecessor, the National Hotel, had been destroyed in a fire in 1872. The area just to the right of Fountain Street church, in the center foreground, is now the site of Grand Rapids Community College. (Baldwin/Dilley.)

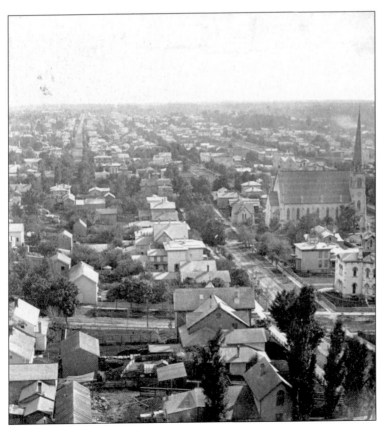

This view, probably from the same location, is looking due south. At the right, is the First (Park) Congregational Church, with Ransom Street at its rear. The area at the center behind the church here remains residential, but in the years after this view was taken, it would become the site of the St. Cecilia Building and a number of commercial structures. Fountain Street is in the foreground, running up the hill to the east. The street at the left is Jefferson Avenue, still a largely residential area. (Baldwin/GRPL.)

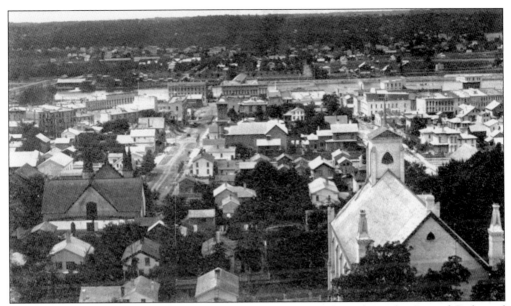

This view from about 1872 looks west over downtown. At the right is the Second Reformed Church on Barclay Avenue, which was destroyed by fire in 1895. The street at the center is Pearl Street, at the far end of which Sweet's Hotel is visible at Campau Square. The Ledyard Block, which now stands at the corner of Pearl Street and Ottawa Avenue, two blocks west of St. Mark's Episcopal Church, was still two years into the future. (GRPL.)

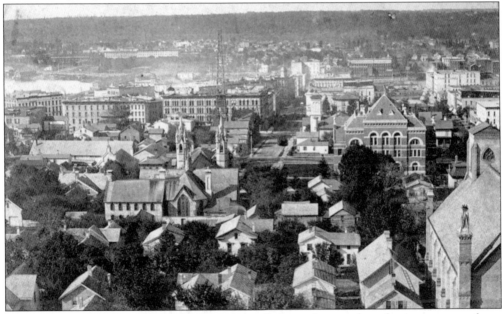

This is almost the same view as the previous card, except it was taken about seven years later. The Ledyard Building is now standing at the corner of Ottawa Avenue and Pearl Street, and the twin towers of St. Mark's Episcopal Church have risen to their full height. Just past St. Mark's in the photograph is one of the towers erected around the city in 1877, in an ill-fated attempt to light the city from above. The newly constructed federal courthouse, built in 1879, is at the right. (Baldwin/Dilley.)

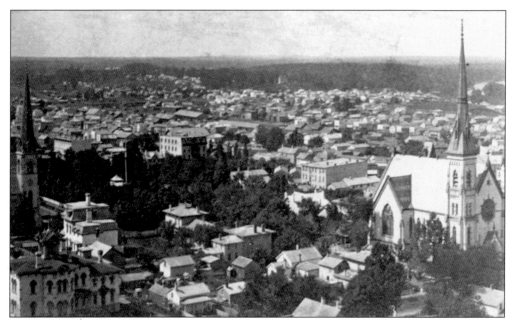

This panoramic view dates from about 1880, and looks southwest from a familiar vantage point. At the right is the Fountain Street Church, built in 1873, and at the extreme left is the spire of First (Park) Congregational Church. The upper part of the spire was removed in 1890, when it began to lean dangerously. At the lower center is the squat roof of the George Allen House, the present site of the Grand Rapids Public Library. In front of that site is Fulton Street (now Veteran's Memorial) Park. (Baldwin/Dilley.)

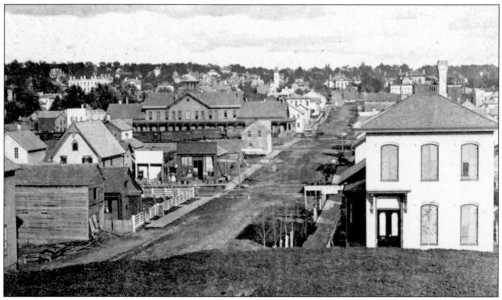

This is a view looking west down Island (now Weston) Street. In the distance is the first Union Railroad station, built in 1870, at Island and South Ionia Avenue, just south of the present site of Van Andel Arena. Reflecting the explosion in rail traffic into Grand Rapids in the last half of the 19th century, this train station was replaced with a much larger facility in 1900, which continued in use until 1961, when it was removed for expressway construction. (Baldwin/Dilley.)

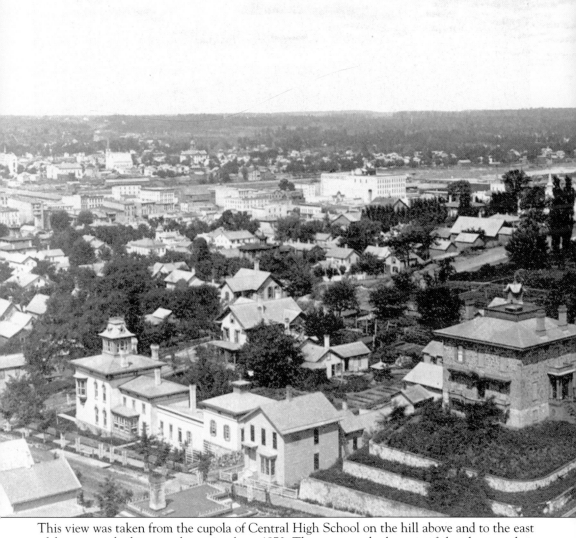

This view was taken from the cupola of Central High School on the hill above and to the east of downtown, looking northwest in about 1870. The street at the bottom of the photograph is Lyon Street. At the right is the home of David Leavitt, built in 1858, at the corner of Lyon Street and Ransom Avenue, now the site of Grand Rapids Community College. The factory building in the distance, at the edge of the river, is the C. C. Comstock factory, makers of wooden pails, tubs, and various milled wood products. (Baldwin/Dilley.)

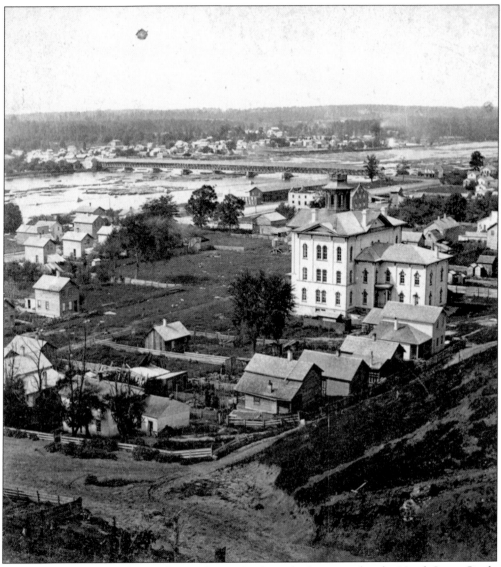

This view looks still farther to the northwest. In the right foreground is the North Ionia Grade School. In the distance is the original Leonard Street covered bridge, built in 1857. Unlike several other spans over the river, this bridge survived the logjam of 1883 and was replaced, as the city grew, in the following decades. (Baldwin/GRPL.)

Two

DOWNTOWN GRAND RAPIDS

Over the last several decades of the 19th century, the changes and development of Grand Rapids, from a village on the banks of the Grand River into the beginnings of the great city it was to become, were nowhere more evident than in the nearly constant changes in the size and appearance of the downtown area, primarily on the east side of the river. Here hotels, office blocks, and great commercial firms, as well as factories and early transportation systems, heralded the creation of a city that differed from all the other tiny settlements in the area in that it was becoming a hub of commercial, governmental, and cultural activity for all of western Michigan. At the time, modest financial investment, and a commitment to hard work, promised, and not infrequently delivered, success and financial reward to inhabitants who had arrived from the east only a few years before, looking for a first, or sometimes a second, chance on new, largely unsettled land. Streets and lots were laid out and quickly filled with buildings of all sizes and purposes, photographs of which provide the first clues of what, over the following one 150 years, was to come.

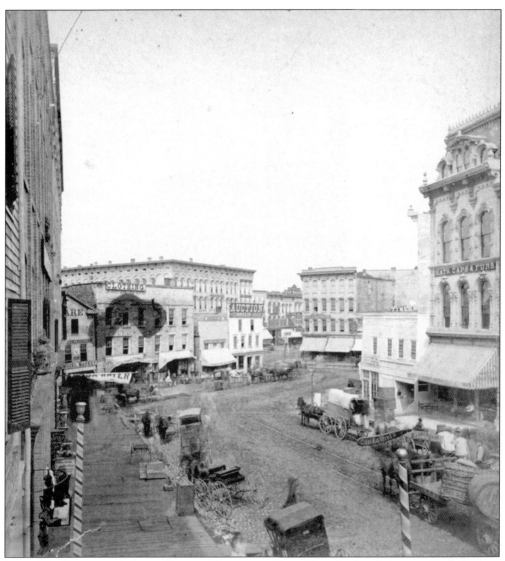

One of the first views of the very heart of downtown Grand Rapids, then known as Grab Corners (now the site of Rosa Parks Circle), is seen here. Monroe Avenue runs from the right side of the photograph to the center, and Pearl Street, although not visible here, is behind the buildings at the right. This jumbled arrangement of thoroughfares arose from a squabble between early settlers Louis Campau and Lucius Lyon, each of whom had acquired parts of the vacant land upon which Grand Rapids now sits, Lyon north of Pearl Street and Campau to the south. Both men laid out their intended streets, and Campau refused to have his aligned with those of his rival, resulting in the sometimes irritating angles in the downtown streets running north to south. The greatest difficulty was presented by Campau's refusal to connect Lyon's Canal Street (now lower Monroe Avenue) to his own angled Monroe Avenue, resulting in the zigzag traffic pattern visible here in a photograph from 1870, taken from the upper floor of the Rathbun House Hotel at the corner of Market Street. (Baldwin/Dilley.)

By 1873, the citizens had had enough, and the city took the necessary steps to acquire and remove buildings that had been built in what was to become Campau Square. That same year, Monroe Avenue and Canal and Pearl Streets were all joined at Campau Square, in an arrangement that remained until just over 100 years later, when Monroe Avenue was extended to the south, through a block of dime stores. Here Sweet's Hotel, built in 1868 and now the site of the Grand Plaza Hotel, is visible. (Baldwin/GRPL.)

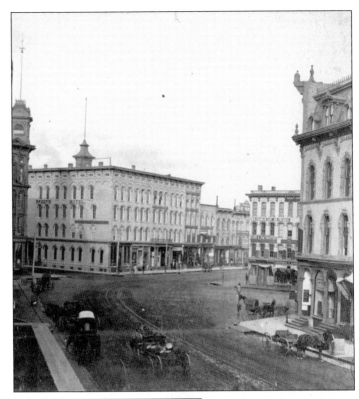

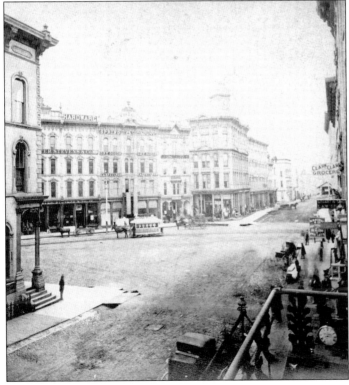

This is a view looking west on Pearl Street, into Campau Square, from the late 1870s. This photograph was taken from the third-story balcony of the Crane Museum of Oddities, a private museum of curiosities, on the site of the present Ellis Parking Garage. (Baldwin/Dilley.)

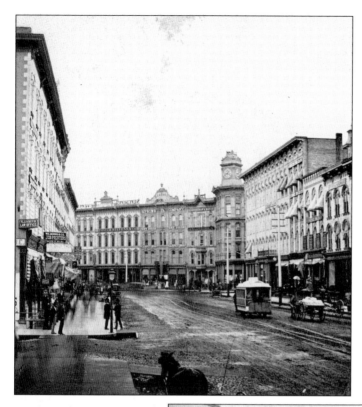

The 1876 view on this card is looking south on Canal Street (lower Monroe) from the corner of Lyon Street, into Campau Square. The reconfiguration of Campau Square had been completed, and Monroe Avenue and Canal Street are joined. The large building to the right is Sweet's Hotel, which in 1902 became the Pantlind Hotel. Just beyond it is the Tower Clock Building, a downtown landmark built in 1875 and replaced by a Woolworth store in 1939. (GRPL.)

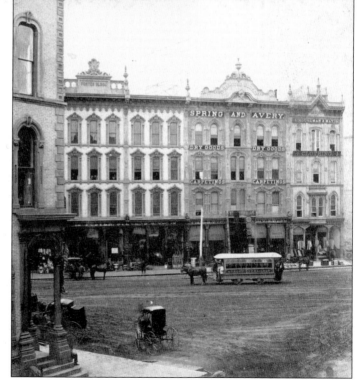

This is a view from Pearl Street, looking across Campau Square, about 1875. The building at the left, the City National Bank, is on the site of the present McKay Tower. Across the square, the Spring and Avery store and the Houseman and May store did a booming business in dry goods and clothing, respectively. (Baldwin/GRPL.)

This *c*. 1878 view looks east across Campau Square, at the site of the present McKay Tower, and up Monroe Avenue to the right. (Baldwin/GRPL.)

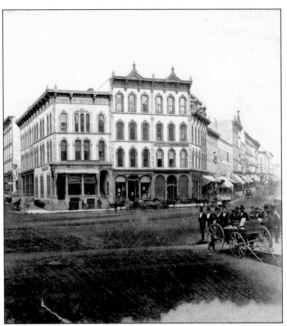

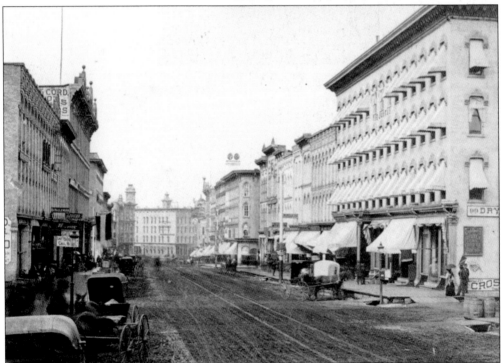

Monroe Avenue was, in 1873, and remains the main street in downtown Grand Rapids. Here the view looks west down Monroe Avenue toward Campau Square. At the right is the then newly constructed Morton House Hotel, before the addition of two upper floors. It was replaced by the present structure, at the corner of Monroe and Ionia Avenues, in 1923. Farther down the street at Campau Square, Sweet's Hotel, the principal competitor of the Morton House, is visible. (Baldwin/Dilley.)

25

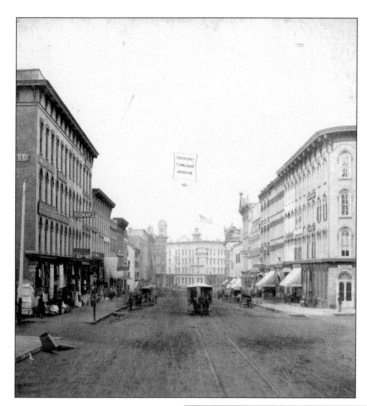

This is the same view as the previous photograph but from a block farther west, toward Campau Square. The brick block at the right, at the corner of Ottawa Avenue, was built just after the Civil War. It stands today and is one of the oldest buildings in the downtown area in continuous commercial use. In the center of the photograph, high above the street on a cable, is a commercial sign advertising a local clothing store. (Baldwin/GRPL.)

Looking east up Monroe Avenue in about 1880, at the right of this view is a row of mercantile stores, replaced in the 1930s by a row of dime stores that have since been removed to allow the extension of Monroe to the south. This is the present site of Rosa Parks Circle. To the left is the site of the McKay Tower. (Baldwin/GRPL.)

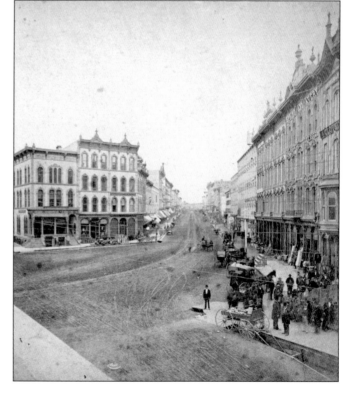

This 1880 view, looking east up Monroe Avenue, was taken from the second-story window of the Spring and Avery dry goods store, located at Campau Square. The busy street is visible over the rolls of carpet displayed in front of the store. (GRPL.)

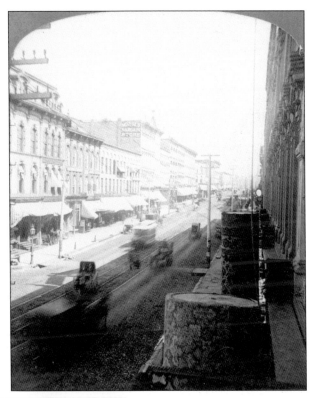

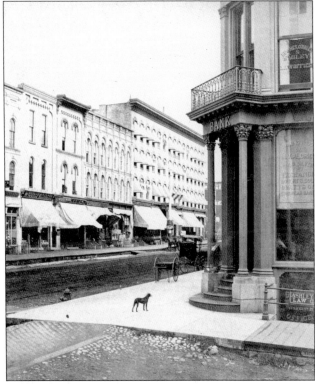

This is the corner of Market Street and Monroe Avenue, looking east. Across the street is the Morton House Hotel, built in 1872. This view is from 1878. (Baldwin/GRPL.)

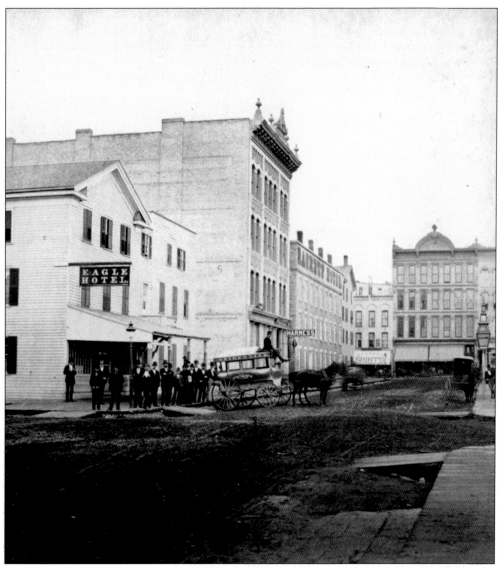

This is a view of Market Street from 1878, looking north toward the intersection of Monroe Avenue, the present site of the new Grand Rapids Art Museum. At the left is the Eagle Hotel, the first hotel in Grand Rapids, originally operated by Louis Campau. The building was expanded several times, burned in 1883, and was replaced by a brick structure, which was razed in 1933. The Rathbun House Hotel, farther up the street at the corner of Monroe Avenue, which began its life as the home of Louis Campau in 1836, was later greatly expanded, and finally was taken down in 1885. (GRPL.)

This view looks north down Canal Street (now Monroe Avenue) from Campau Square in about 1878. At the left is Sweet's Hotel, later the Pantlind Hotel. (Baldwin/Dilley.)

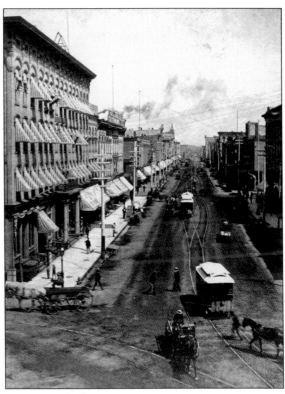

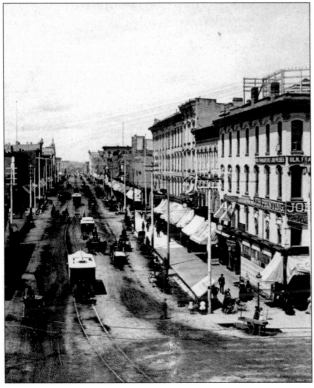

This is another view looking north on Canal Street from Campau Square. At the right is the Lovett Block, which still stands, although in a much renovated state. Farther down the street are several blocks of retail stores, able to provide local shoppers with virtually anything they might want or need. (Baldwin/Dilley.)

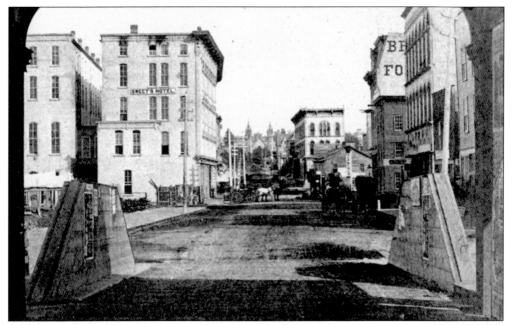

Pearl Street is the third street that crosses Campau Square, from east to west. This *c.* 1875 view is looking east from the eastern edge of the covered street bridge, which was constructed over the Grand River in 1858. On the left is the side of Sweet's Hotel, and at the distant center, past the site of the present McKay Tower, are the twin towers of St. Mark's Episcopal Church. (Baldwin/GRPL.)

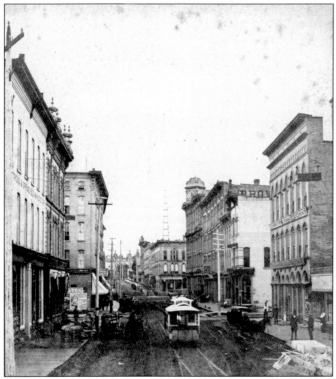

This is another view up Pearl Street, also from the river's edge, taken shortly after the completion of the Tower Clock Building on Campau Square in 1875, at the center right. In the center distance is one of several towers erected by the city in 1878 in a rather odd and unsuccessful effort to light the city from above. The base of the tower was situated at the corner of Ottawa Avenue and Pearl Street, next to the home of William "Deacon" Haldane, the pioneer resident credited with the beginning of the furniture industry in Grand Rapids. (Baldwin/Dilley.)

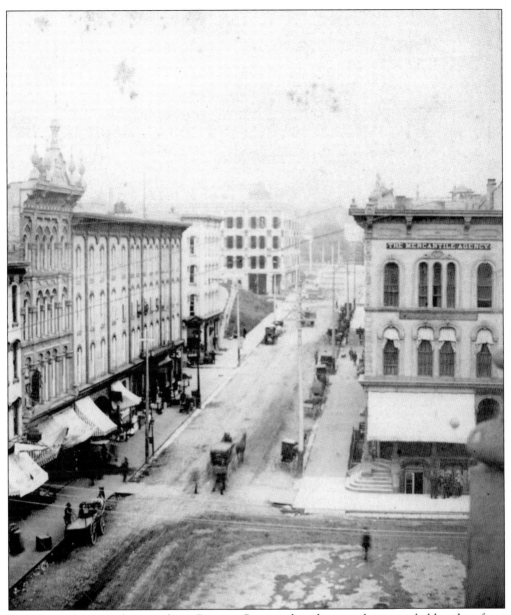

Looking east on Pearl Street from Campau Square, this photograph was probably taken from the roof of the Tower Clock Building, completed in 1875. At the right, the City National Bank stands on the current site of the McKay Tower. At the center left is the Powers Opera House, and farther up the street, at the left, is the Houseman Building, here under construction and competed in 1883. Just in front of the Houseman Building in the picture, on the present site of the Waters Building (built in 1899), the last remnant of Prospect Hill is visible. The hill existed in the middle of the downtown area and was gradually leveled out of existence between about 1860 and 1885. This high ground would be completely removed in the next decade as homes originally built in this area were removed and the neighborhood became completely commercial. (GRPL.)

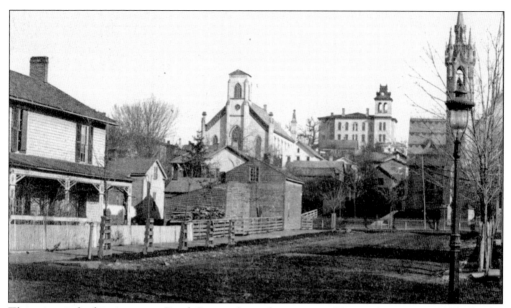

This view is looking east on Pearl Street, from the corner of Ionia Avenue, in 1875. At the left, the home of Daniel Tower occupies the site of the first and second federal courthouses in Grand Rapids, built in 1879 and 1909, respectively. In the center distance is the Second Christian Reformed Church, built in 1870 and lost in a fire in 1895. On the hill in the center is Central High School, built in 1868. At the right is one of the two towers of St. Mark's Episcopal Church. (Baldwin/GRPL.)

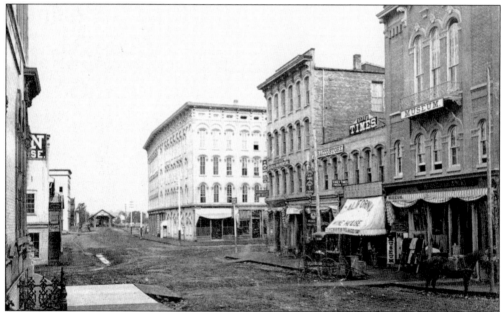

This view looks down Pearl Street toward the river, from just west of Ottawa Avenue, in about 1870. The Crane Museum of Oddities, a Barnum-style display of "freaks, snakes and whiskered ladies," is at the right, with the Lovett Block, Canal Street (now Monroe Avenue), and Sweet's Hotel beyond. In the distance, at the end of the street, the entrance to the covered Pearl Street bridge is visible. (Baldwin/GRPL.)

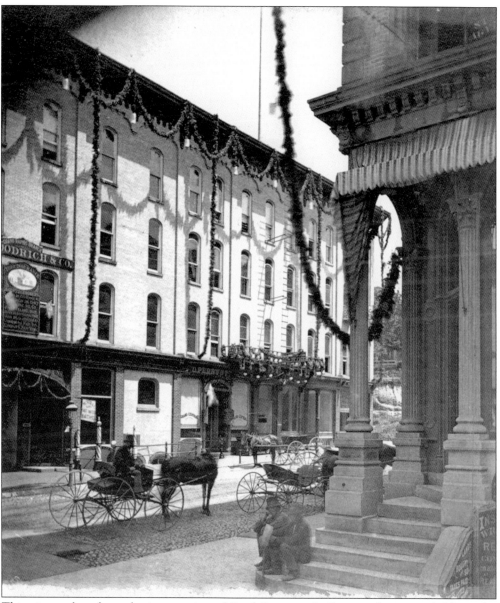

This view, taken from the intersection of Pearl Street with Campau Square probably at the time of the centennial celebration in 1876, looks up Pearl Street, to the east. At the left is the entrance of the City National Bank, now the site of the McKay Tower. Across Pearl Street, in the center of the photograph, is the Powers Opera House, then and for many years thereafter the focus of many stage performances in Grand Rapids. At the left edge of the photograph is a pedestrian arcade that ran through the buildings here to Lyon Street. The arcade existed at this location for many years and was the location of a variety of small shops and businesses. Although the public right-of-way still exists, the removal of the building here many years later ended its use as a commercial thoroughfare. The Ellis Parking Company parking ramp sits on this site today. (Horton/GRPL.)

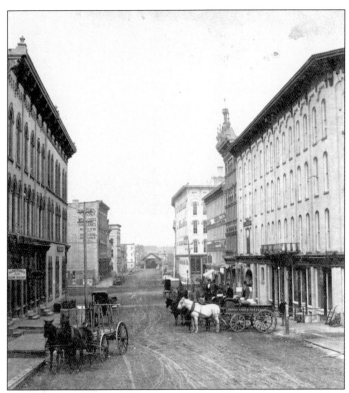

In this view down Pearl Street, from about 1878, the street is still unpaved and populated with horse-drawn vehicles. Crane's Museum has disappeared, replaced by the Powers Opera House and the arcade building. The covered bridge over the river, at the center, is still visible. (Baldwin/GRPL.)

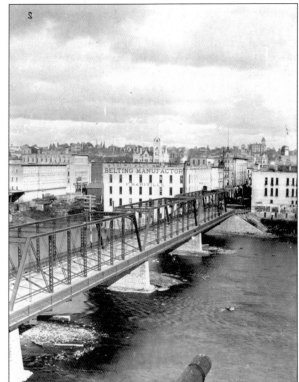

After the great logjam and flood of July 1883, the original covered Pearl Street bridge was replaced with this iron structure in 1885. The view here is looking west, across the river. This bridge was itself replaced with a cement span in 1922. (GRPL.)

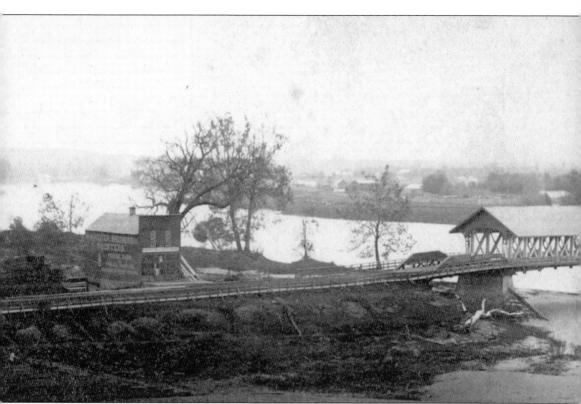

This very early stereograph shows the eastern end of the covered Pearl Street bridge shortly after its construction in 1858. The channel between the shore and one of the islands that hugged the eastern bank of the river has been filled to extend Pearl Street to the bridge. The land on the near side of the street, filled with earth taken from the leveling of Prospect Hill a few years after this photograph, is now the site of the tower of the Grand Plaza Hotel. The Forslund Condominium building is located on the far side of the street, at the river's edge. The small building at the center of the photograph is thought to be the first mortuary business in Grand Rapids. (GRPL.)

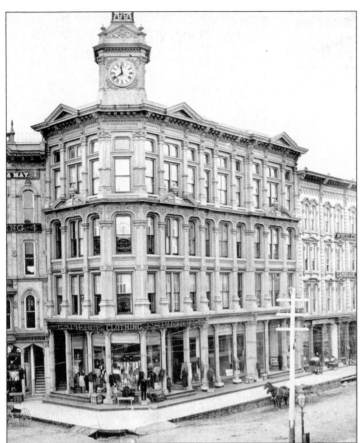

The Tower Clock Building, at the corner of Pearl Street and Monroe Avenue, at Campau Square was built in 1875 and over the years housed many different businesses, including E. S. Pierce's Great Wardrobe clothing store and the Fourth National Bank. The building was razed in 1939 and replaced with the art deco Woolworth store, which was demolished in the late 1970s for the extension of Monroe Avenue and the construction of the present National City Bank building on the site. (Baldwin/Dilley.)

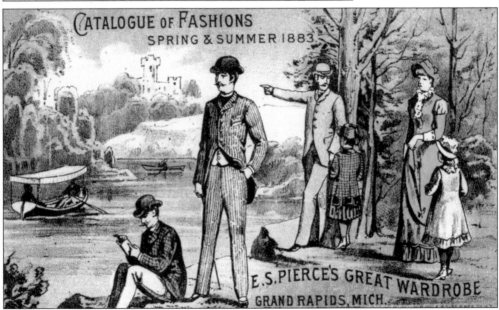

This is an 1883 trade card published and distributed by E. S. Pierce's Great Wardrobe, illustrating the full range of clothing that the store offered. (Dilley.)

Another trade card, also published and distributed by the E. S. Pierce Company, illustrates the Tower Clock Building built by the firm at the corner of Pearl Street and Monroe Avenue in 1875. (Dilley.)

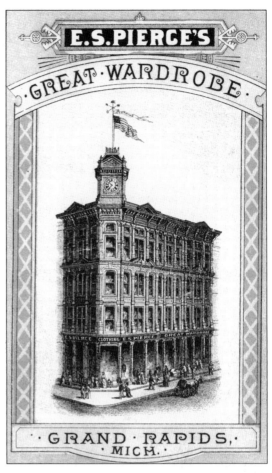

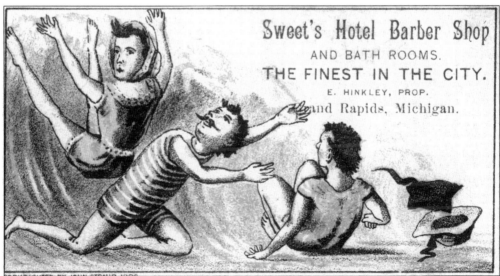

One of a series of small, somewhat ribald trade cards that were issued by the barbershop at Sweet's Hotel, for its gentlemen customers, in about 1880, is shown here. (Dilley.)

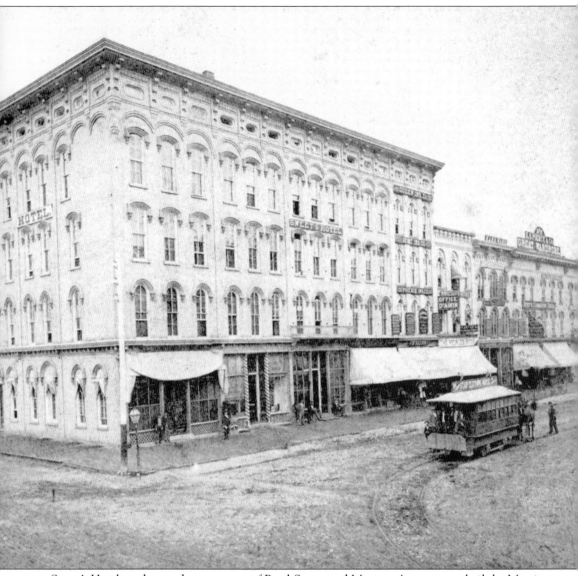

Sweet's Hotel, at the northwest corner of Pearl Street and Monroe Avenue, was built by Martin L. Sweet, a local miller and investor said to be the richest man in Grand Rapids, in 1868. In 1874, this and other buildings on Monroe (then Canal Street) were raised four feet to meet a regrading of the street, all while business continued to be conducted. In 1902, after a financial panic had wiped out Sweet's fortune, the hotel was taken over by J. Boyd Pantlind and renamed the Pantlind Hotel. This building, as well as all the others on the block, was taken down in 1915 for the building of a much larger Pantlind Hotel, which in the 1970s became part of the Grand Plaza Hotel. (Baldwin/Dilley.)

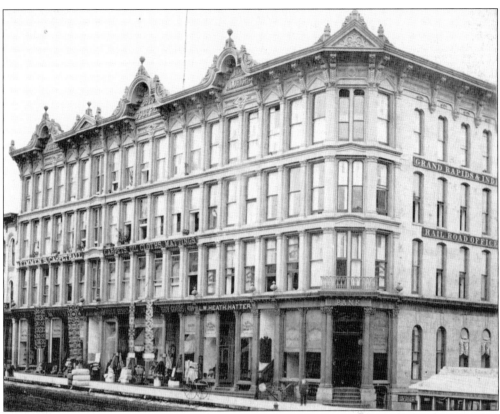

Located at the corner of Ottawa Avenue and Pearl Street, the Ledyard Building was one the first large business blocks to be put up in Grand Rapids, in 1874. It sits on a part of the old Prospect Hill area and required the removal and grading of large amounts of earth to level and grade the site before construction. During its lifetime, the building has housed the YMCA, the public library, and many businesses. It continues in a mixed business use today. (Baldwin/Dilley.)

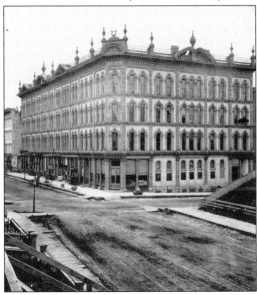

Here is another view of the Ledyard Building, from about 1874, shortly after its completion. On both sides of Ottawa Avenue, at the bottom of the picture, the remains of Prospect Hill, which had yet to be leveled completely in this neighborhood, are visible. At the right foreground is the site of the Waters Building, built in 1899, and across the street, to the left in the picture, is the site of the Houseman Building, built in 1883 and razed in 1966 for a parking lot. (Baldwin/GRPL.)

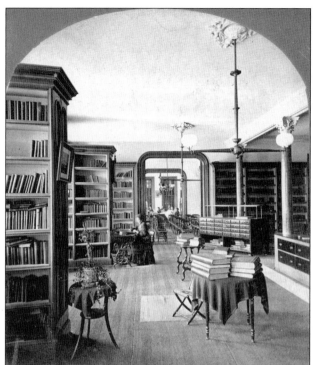

This view shows several of the rooms of the fledgling Grand Rapids Public Library, housed on an upper floor of the Ledyard Building, in about 1875. After a brief stay at this location, the library moved to quarters in the Grand Rapids City Hall, after its completion in 1888, where it stayed until the completion of the Ryerson Public Library, at the corner of Bostwick Avenue and Library Street, in 1904. (GRPL.)

This is a somewhat later stereograph view of the newly completed Grand Rapids Press building, located at the corner of East Fulton Street and Sheldon Avenue, from 1906. The photograph was taken from Fulton Street (now Veteran's Memorial) Park, across the street. This building, when completed, was one of the first in the world to be built of reinforced concrete construction. (Dilley.)

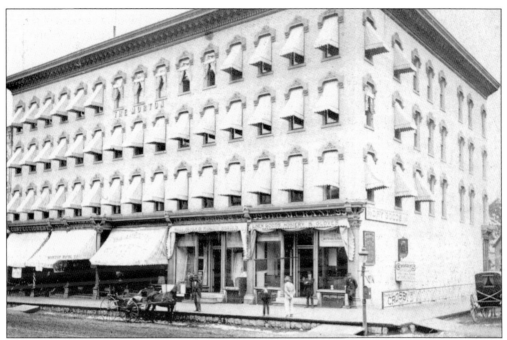

The Morton House Hotel, located on Monroe Avenue at the corner of Ionia Avenue and seen here in about 1875, is actually the second of three hotels that have stood on this site. The first opened as Hinsdill's in 1836 and was later renamed the National. The original building burned in 1872 and was replaced by this building and renamed the Morton House at that time. Several floors were later added to the top of this building before it too was replaced in 1923 by the building that remains at the site. (Baldwin/Dilley.)

This view looks west, down a bustling Monroe Avenue, toward Campau Square in the late 1870s. At the right is the Morton House Hotel, after the addition of several stories to the building pictured in the previous view. (Dilley.)

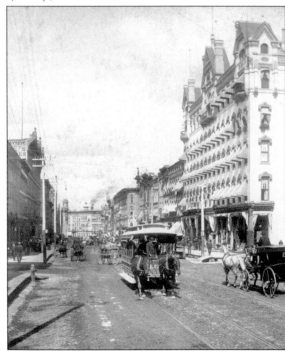

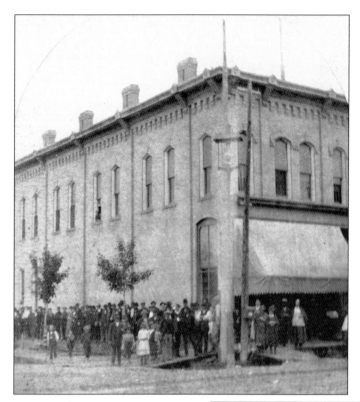

This view shows a retail store at an unknown location in the downtown area. The crowd pictured was likely attracted by the stereo photographer who took the picture. Note the elevated wood sidewalk, made necessary by the lack of paving in the streets, which became particularly messy in rainy or winter weather. (Barrows/Dilley.)

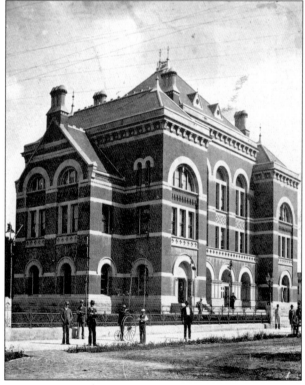

The first federal building in Grand Rapids was built in 1879, the year this photograph was taken, on Ionia Avenue between Pearl and Lyon Streets. It housed all federal government functions, including the postal service, courts, and miscellaneous federal offices. The building was outgrown in 30 years and was replaced, on the same site, in 1909. Note the velocipede bicycle on the sidewalk in front of the building. (Baldwin/Dilley.)

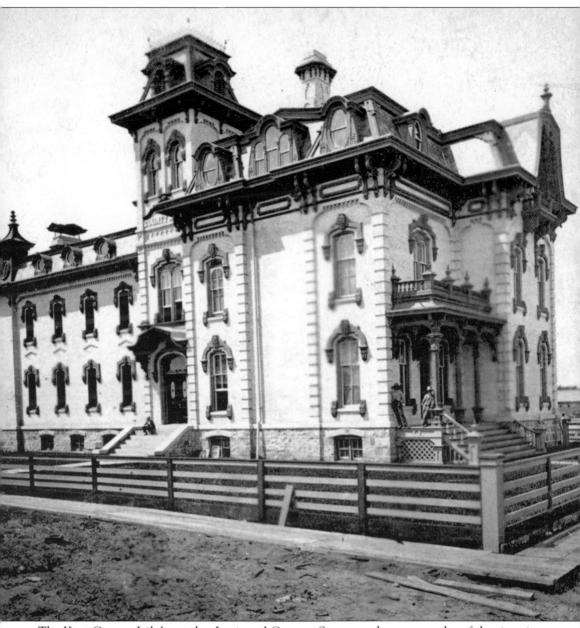

The Kent County Jail, located at Louis and Campau Streets at the eastern edge of the river, is pictured in about 1875. Actually built on one of the three islands that were close to the eastern riverbank in 1871, it included facilities for housing prisoners, an exercise yard, and the residence of the county sheriff. Later the canal was filled and the riverbank farther extended, "moving" the jail farther from the river's edge. This building continued in use until 1958, when a new jail was built east of downtown, and this building was taken down. The site is now the parking lot of the Old Town Riverfront Building. (Baldwin/GRPL.)

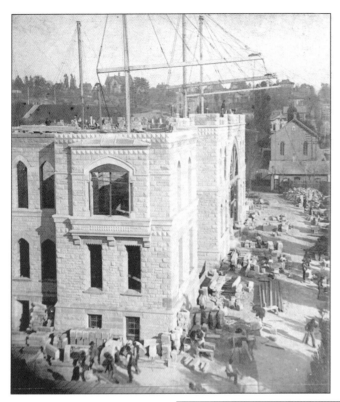

This remarkable picture records the actual construction of the Grand Rapids City Hall in 1887–1888. Pictured here are the first several stories of the clock tower on the southwest corner of the building. (GRPL.)

Faced with no adequate facility in which to hold their annual musical festivals and conventions, Grand Rapids area German immigrants built this building, the Saengerfest Hall, on the south side of Lyon Street between Canal Street (now Monroe Avenue) and Ottawa Avenue in 1877. The building included a large stage and a taproom decorated with many beer steins. It was used for many gatherings over its short life, including several political conventions. The building burned to the ground in May 1882. (GRPL.)

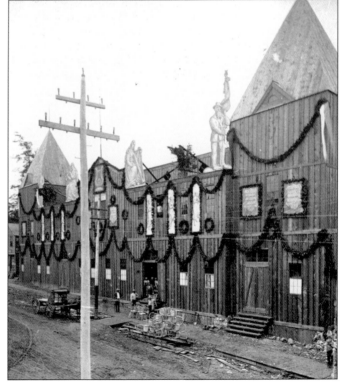

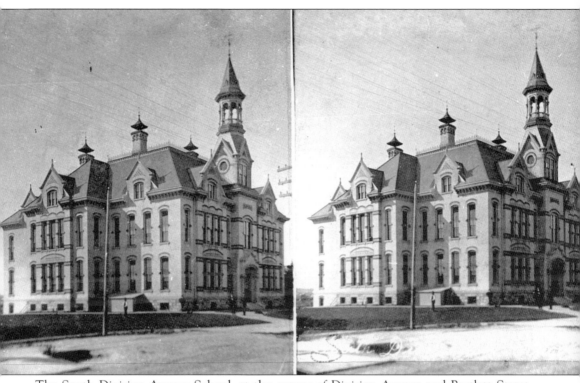

The South Division Avenue School, at the corner of Division Avenue and Bartlett Street, is seen here shortly after its completion in 1884, at a cost of $34,000. The school was the largest elementary school in the city at the time, housing some 700 students. The school was used well into the 20th century, although in its later years only for storage purposes. It was taken down in 1948, and 14 years later, the offices of the Michigan Employment Security Commission were built on the site. That building has since been converted to use by the Guiding Light Mission. (GRPL.)

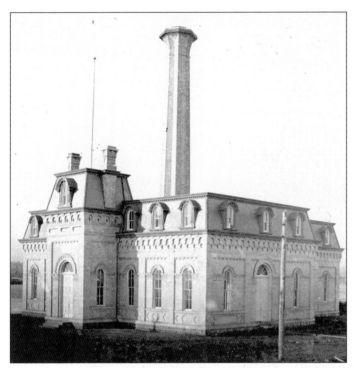

The pump facility of the Grand Rapids water system, at the intersection of Monroe Avenue and Coldbrook Street north of downtown, was built in 1874, the same year this photograph was taken. The pumps here could draw water from Carrier and Coldbrook Creeks and, of course, the Grand River for use by the growing city. After nearly 80 years of use, a more modern facility was built on the same site, incorporating parts of this original building. (Baldwin/GRPL.)

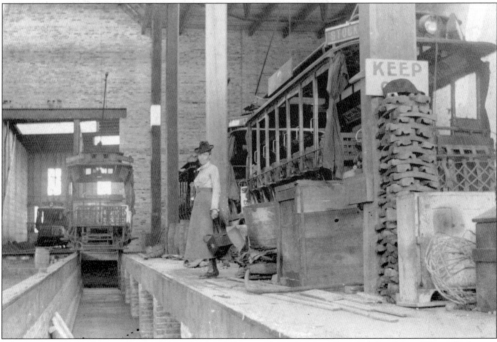

This is an unusual view, from about 1900, of the machine/repair shop of the Grand Rapids Street Railway Company, located at Hall Street just east of Division Avenue, in one of three carbarns located around the city. Here the company's streetcars were brought in for regular inspection and repair before returning to the routes of the system, which, by this time, had become quite important to the growing city. (Dilley.)

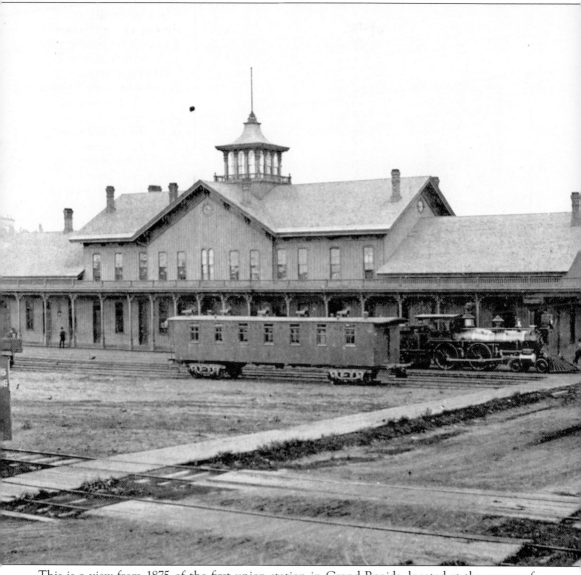

This is a view from 1875 of the first union station in Grand Rapids, located at the corner of Island Street (now Weston Street) and South Ionia Avenue and built in 1870. Railroads first arrived in Grand Rapids in 1858, with service by the Detroit and Milwaukee Railroad. Later the Grand Rapids and Indiana Railroad, whose locomotive is pictured on the platform here, along with many others, joined in heavy freight and passenger traffic, which lasted until just after World War II. Once established, railroad traffic in and out of the city became heavy, exceeding 25,000 trains each year by 1910. A larger facility at the same site replaced this station in 1900, and it was ultimately razed in 1961 for expressway construction. This site is presently just behind the Van Andel Arena. (Baldwin/GRPL.)

The Grand Rapids and Indiana Railroad was first incorporated in 1858 and a few years later began freight and passenger service to Grand Rapids and points south. This is the headquarters building of the railroad, built at that time, which stood adjacent to Union Station on South Ionia Avenue, behind the site of the present Van Andel Arena. (GRPL.)

This view from 1884 is of the Detroit and Muskegon depot, located on Plainfield Avenue north of downtown. At the right above the train shed, the location of Lookout Park and the municipal reservoir on the hill to the east of the city is visible. (Barrows/Dilley.)

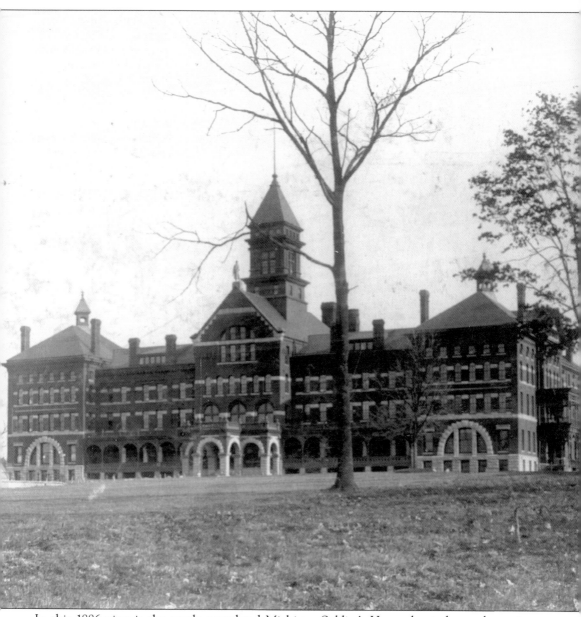

In this 1886 view is the newly completed Michigan Soldier's Home, located on a large site overlooking the Grand River on Monroe Avenue, north of the city. Originally established to house aging disabled veterans of the Civil War, this building was one of the first such facilities in the country. The building shown was later joined by a number of other buildings, including one to house the widows of veterans on this site. This building was demolished and replaced with the present structure in the early 1970s. (Walter/Dilley.)

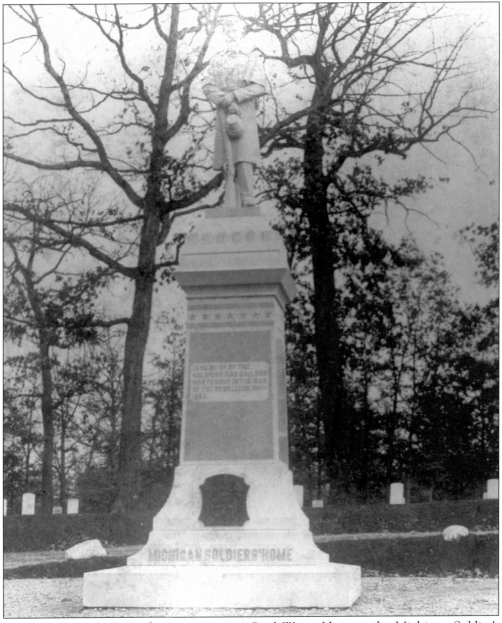

This *c.* 1890 view shows the monument to Civil War soldiers at the Michigan Soldier's Home. (Walter/Dilley.)

Three

A City of Homes and Churches

The city of Grand Rapids grew gradually during, and more rapidly after, the Civil War years, and this growth, of course, brought not only greater industry and prosperity but also a larger population. In the years between 1860 and 1885, the resident population of 8,000 doubled and then doubled again, and with this growth came an expansion of residential neighborhoods and the churches that dotted them. The stereographic record of the residential areas of the city at this time, as the views that follow illustrate, is far from comprehensive or complete. Many neighborhoods, and many churches, that existed at the time were never photographed, but those that were provide views of parts of the city, and some of its noncommercial buildings, that were central parts of the lives of the city's inhabitants.

Most of the stereographs of local churches, both inside and out, were taken because of their beauty and prominence in the community and as such, probably had some commercial-sale appeal. Many of the scenes of private homes, however, were likely commissioned by proud homeowners, who wanted a novelty view of their family home, to share with friends and family members and as such, had little sale value to others. These views do, however offer a glimpse of the lifestyle of some of the residents of the city at the time, when people dressed heavily and never casually and lived lives of considerable formality typical of late-Victorian America.

This is a c. 1875 view of Fountain Street, looking east from the top of the hill, at the intersection of Prospect Avenue. This street, which runs east and west through the very heart of the district now known as Heritage Hill, on the hill above and to the east of downtown, here appears peaceful and parklike and has not yet experienced the boom in the construction of the large and stylish homes of the great and powerful of Grand Rapids, which was to come in the decades that followed. At the left is the site of Central High School, built in 1910. (Baldwin/Dilley.)

Fulton Street, probably from the corner of College Avenue looking east, is seen here in approximately 1870. At the extreme left, out of the picture, is the site of the home of early pioneer resident John Ball, the present site of Central Reformed Church. Across the street, at the right side of the photograph, is the northern edge of the estate of Dudley Waters and the present site of the Waters House Apartments, built in the 1960s. About halfway down the street on the right is the intersection and beginning of Lake Drive. (Baldwin/Dilley.)

This view of Jefferson Avenue, south of Fulton Street, is from about 1875. This is a street that, particularly at the nearest end in the photograph, quickly became largely commercial toward the end of the 19th century, as it remains today. In this view, the street remains unpaved and is lined by the many tress that disappeared with street widening and development over the years. (Baldwin/Dilley.)

53

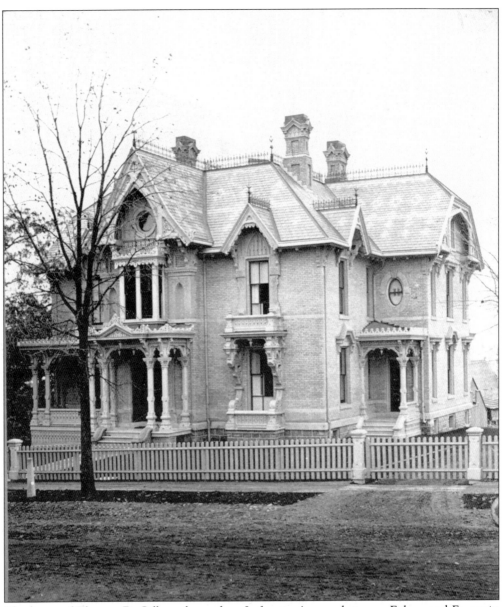

The home of Thomas D. Gilbert, located on Lafayette Avenue between Fulton and Fountain Streets in the Heritage Hill district, is shown here around 1880. Gilbert was a successful banker in Grand Rapids and served over the years as city alderman and both official and unofficial parks commissioner. He was personally responsible for the development of Fulton Street Park, played a central role in the acquisition and development of John Ball Park, and was involved in the incorporation of the first public cemetery in Grand Rapids, located at the intersection of Fulton Street and Eastern Avenue. (GRPL.)

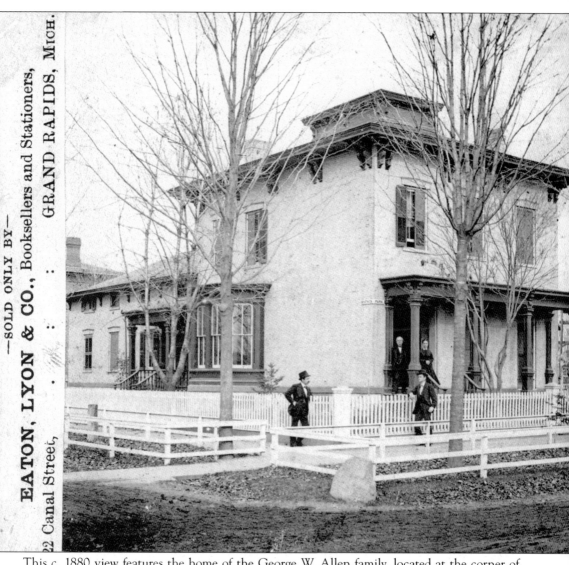

This *c.* 1880 view features the home of the George W. Allen family, located at the corner of Bostwick Avenue and Library Street on the site of the present Grand Rapids Public Library. This neighborhood, on the eastern edge of the downtown area, remained largely residential until the end of the 19th century. The corner was acquired for the construction of the library in 1901 by Martin A. Ryerson, a wealthy Chicago industrialist who built and furnished the ornate Renaissance Revival library building for the city in 1904. Ryerson was born in Grand Rapids and was a direct descendant of Louis Campau, and his gift to the city rendered moot the application then under consideration for a library to be provided by another steel magnate, Andrew Carnagie. (Baldwin/GRPL.)

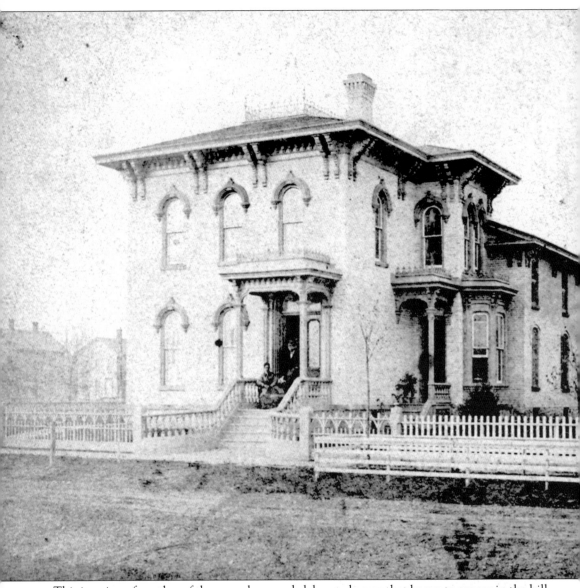

This is a view of another of the many large and elaborate homes that began to appear in the hill district of Grand Rapids in the 1870s and 1880s. As was true of similar districts in other cities, these great homes fell into disuse in the early part of the 20th century as taste and the city itself began to change and their owners relocated to other neighborhoods east of town. Unlike other cities, however, through the tireless efforts of a number of preservationist-residents, the majority of the hill district was saved from the ruthless demolition of the 1960s and remains today as a unique historic residential area. (Baldwin/Dilley.)

The home of William
Widdicomb, on Fountain
Street in the hill district,
is seen here in about 1880.
Widdicomb was the eldest
of the four sons of George
Widdicomb, a pioneer
furniture manufacturer
in Grand Rapids. After
serving in the Union
army during the Civil
War, William returned to
Grand Rapids and, with
his three brothers, started
the Widdicomb Furniture
Company, makers of
household, bedroom, and
parlor furniture, in
1873. (Baldwin/Dilley.)

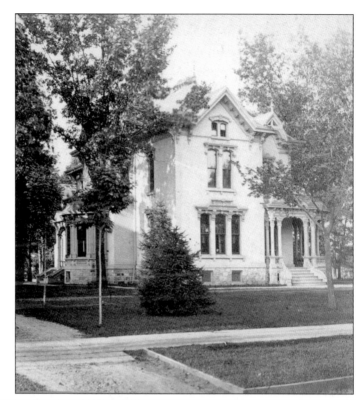

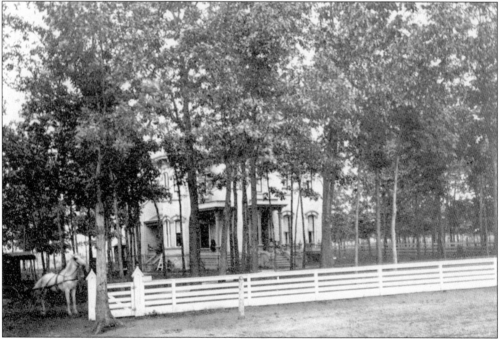

The Philander Livey Home, on Lake Drive east of Fulton Street, is shown in around 1875,
when the area was close to the eastern city limit and it still maintained much of its rural
quality. (Baldwin/GRPL.)

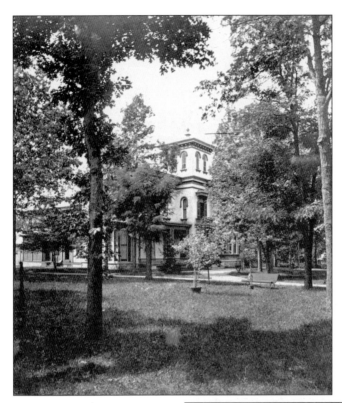

This view shows the large Italianate mansion of Robert W. Morris, located at the corner of Cherry Street and Morris Avenue, from about 1880. Morris was an early settler in Grand Rapids, arriving here in 1837, when he entered the lumber and lumber milling business with partner Martin A Ryerson. The firm owned several mills in Muskegon, as well as the first steamship operated between that city and Chicago. (GRPL.)

In 1865, Morris acquired the 20-acre Bostwick homestead, on Cherry Street in the southeast end of the city, and built this home for his family. Sadly, Morris died the following year. Thereafter, his widow, Sarah, continued his business activities, including the platting and sale of much of the original 20 acres, located in the heart of the Heritage Hill Historic District. (GRPL.)

The David M. Amberg house, located on Cherry Street near the present site of St. Mary's Hospital, is pictured in 1885. After service in the Union army (at the age of 15) in the Civil War, Amberg arrived in Grand Rapids in 1868. Shortly thereafter, he married Hattie Houseman, daughter of prominent local businessman, Julius Houseman. Amberg operated a profitable wholesale liquor firm, and in 1891, at the death of his father-in-law, assumed the management of the Houseman family assets. (GRPL.)

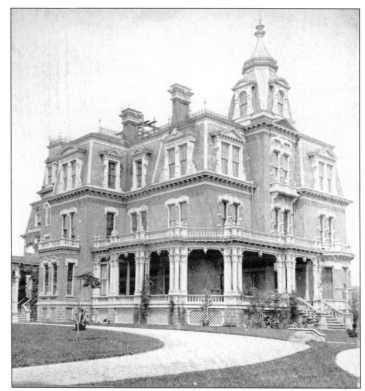

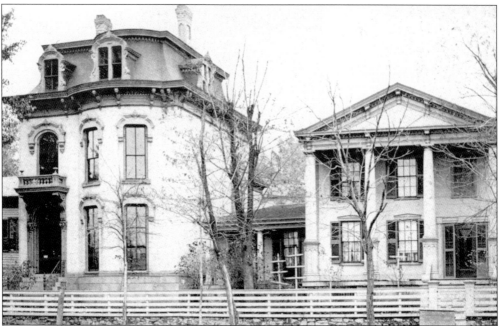

This is a view of the prosperous neighborhood that once existed on the west side of the Grand River, just north of downtown, from about 1880. These homes would have had an unobstructed view of the river from their front windows. This entire area was razed in the 1960s for expressway construction. (Baldwin/Dilley.)

The home of early Grand Rapids pioneer John Ball was located at the corner of College Avenue and Fulton Street and appears here in 1880. This home was later replaced with a larger house on this site, which was itself later removed for the construction of Central Reformed Church in 1957. (GRPL.)

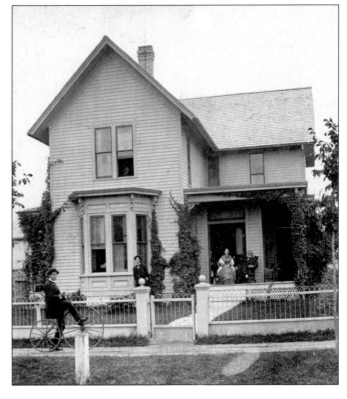

This is the home of Dr. Samuel Graves, the minister of the Fountain Street Church. This stereograph, taken about 1875, is typical of many taken at this time, commissioned by families and homeowners for their own use rather than commercial sale. Here the photographer, Schuyler Colfax Baldwin, recorded the home and family of his sister and brother-in-law. (Baldwin/GRPL.)

This is the Graves family outside of their home, taken about 1875. Joining Graves in the picture is his wife, the sister of the photographer. Sitting in the window is one of two sons of the family, Baldwin's nephew, either Will Graves, later an editor of the *Chicago Tribune*, or the future Dr. S. C. Graves, a medical doctor who attended Baldwin at the time of his death in 1900. (Baldwin/GRPL.)

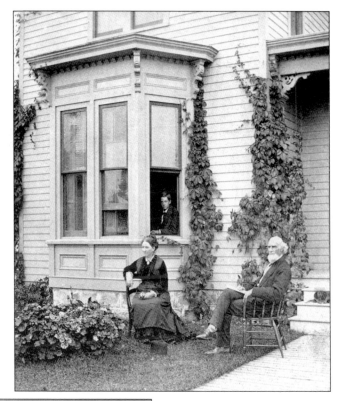

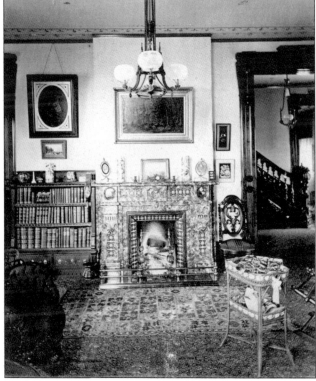

An interior view of the Graves household, also taken by Baldwin, shows the typical Victorian clutter that was fashionable at the time. (Baldwin/GRPL.)

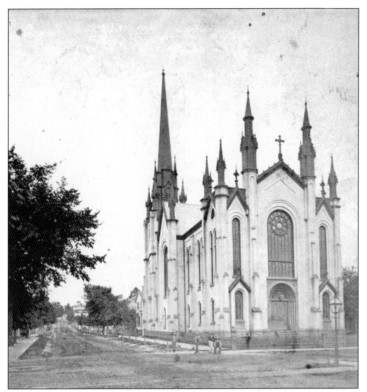

This is the First United Methodist Church, at the corner of Fountain Street and Division Avenue, taken about five years after its construction, in 1869. The building was known by locals as the "church of the holy toothpicks" because of its many spires. The congregation moved in 1917 to a larger building at Fulton Street and Barclay Avenue, where it remains today. This site is now occupied by the Keeler Building. (Baldwin/Dilley.)

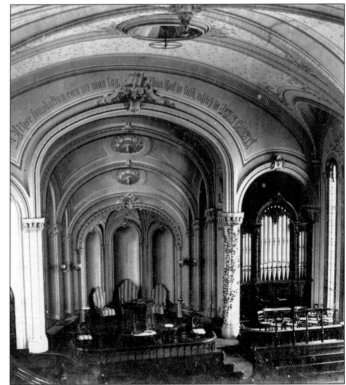

The interior of the First United Methodist Church, at Division Avenue and Fountain Street, is seen in this card from about 1875. (Baldwin/GRPL.)

This view is of the original Fountain Street Baptist Church, at the corner of Fountain Street and Bostwick Avenue, built in 1873. The spire on the church was an amazing 217 feet in height. The entire building was destroyed in a catastrophic fire in 1917 but was rebuilt on the same site in 1924. The spire of its neighbor, the First United Methodist Church, is visible on the right of the photograph. (Baldwin/Dilley.)

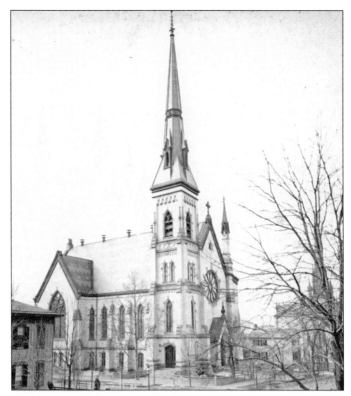

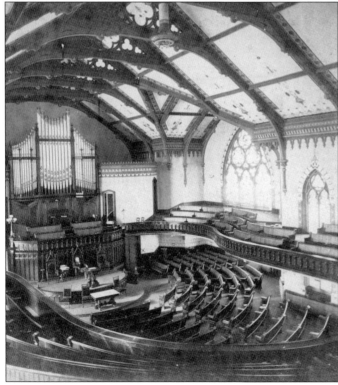

This is the interior of the Fountain Street Baptist Church at the time of its completion in 1873. (Baldwin/Dilley.)

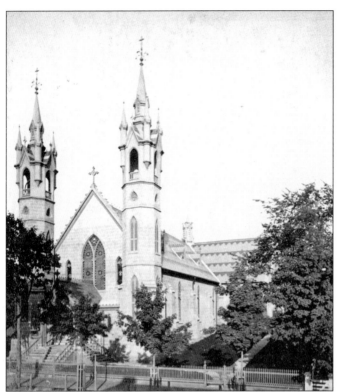

One of the oldest remaining buildings in Grand Rapids, St. Mark's Episcopal Church stands on Division Avenue at the head of Pearl Street. This congregation was founded in 1836, and the church was built in 1848, with limestone dredged from the bottom of the Grand River. The twin spires were added to the church in 1851. This photograph dates from 1878. (Baldwin/Dilley.)

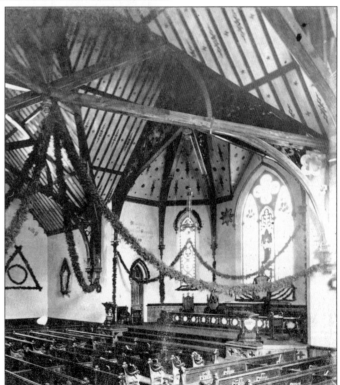

The interior of the St. Mark's Episcopal Church, probably decorated for holiday services, is pictured here in about 1878. (GRPL.)

St. Andrew's Cathedral, located on Sheldon Avenue south of downtown, was built in 1876, shortly before this view was taken. (Baldwin/GRPL.)

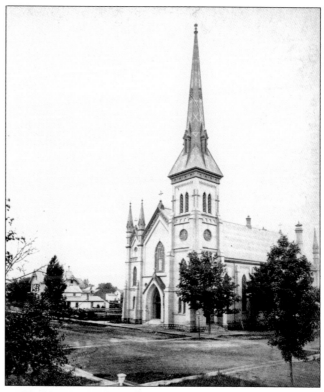

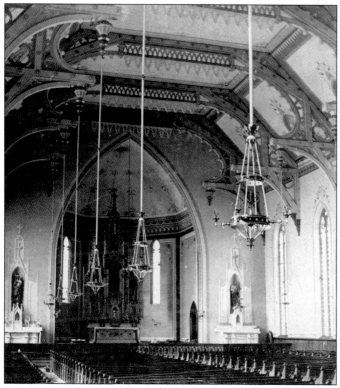

The interior of St Andrew's Cathedral is shown shortly after the building was completed, in 1876. (Baldwin/GRPL.)

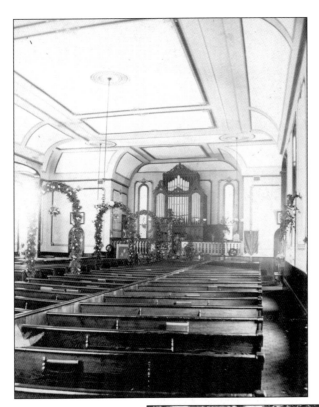

The interior of the Universalist church, located on Pearl Street between Ottawa and Ionia Avenues, is pictured in about 1875. In 1892, the church moved to larger quarters on Sheldon Avenue, south of Fulton Street, where it remains. (GRPL.)

This is a view of part of the Oak Hill Cemetery, located at the corner of Hall Street and Eastern Avenue, from about 1878. In the foreground is the grave site of the Crosby family, for whom this stereograph was probably produced. In the left background is the holding facility in the cemetery for burials that occurred in the winter months, when the ground could not be broken. (Dilley.)

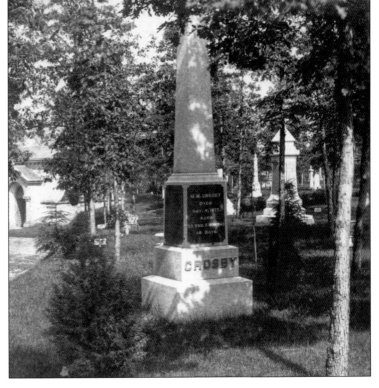

Four

THE STEREOGRAPH
GOES COMMERCIAL

It was not long after the initial appearance and public appreciation of the virtues of stereophotography that its first "serious" commercial uses began to appear. Some of the first such commercial stereographs depicted factories and commercial establishments, commissioned by business owners partly out of vanity, but also to illustrate to others, including potential customers, that their businesses were significant, established concerns, in very much the same manner as the trade cards and picture postcards that were to appear at the end of the 19th century. Soon thereafter, series of views of actual products were created, often to put into the hands of traveling salesmen, who could then show to their customers an actual, three-dimensional photographic view of the machines, or furniture that were being offered for sale. Such stereographic sample cards are rare, because their production was expensive, and other devices, including the catalogues and line drawings of products that had been used for decades before were easier to create and circulate.

In Grand Rapids, a full variety of commerce-related stereographs were created between about 1875 and the end of the 19th century. These cards include views of factories and stores in the city, as well as a number of views clearly intended to promote products manufactured in the city to be sold in markets far away.

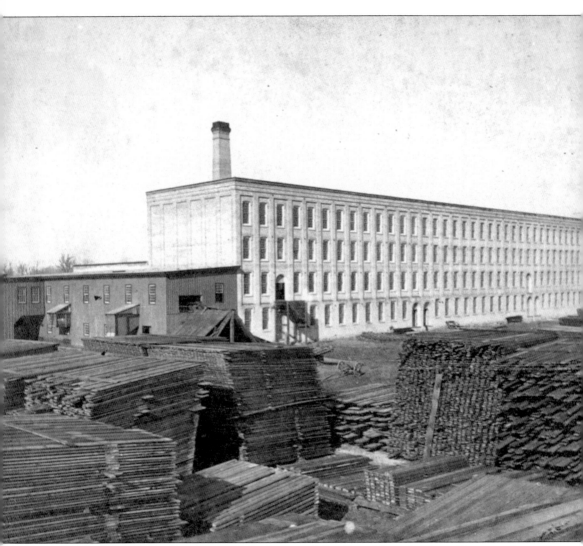

This is a view, from about 1880, of the factory of the Grand Rapids Chair Company, located on Monroe Avenue north of downtown. The company was founded by Charles C. Comstock, Elisha Foote, and others in 1872 and soon boasted a catalog of more than 450 styles of chairs, including some whose cane seats were woven by young inmates at the State Reform School for Children in Lansing. Comstock's success in furniture manufacturing, typical of many of the early manufacturers, came from his involvement in logging and lumber milling operations in the Grand River Valley in the years before the founding of this company. Much later, the company was acquired by the Sligh Furniture Company and still later, the Baker Furniture Company. It disappeared as a separate entity in 1973. (Baldwin/Dilley.)

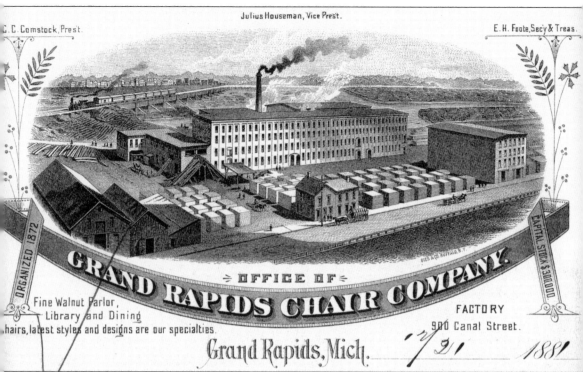

C.C. Comstock, Pres't.

Julius Houseman, Vice Pres't.

E.H. Foote, Sec'y & Treas.

ORGANIZED 1872.

CAPITAL STOCK $300,000.

= OFFICE OF =

GRAND RAPIDS CHAIR COMPANY.

Fine Walnut Parlor,
Library and Dining
Chairs, latest styles and designs are our specialties.

FACTORY
900 Canal Street.

Grand Rapids, Mich. 7 21 1881

GIES & CO. BUFFALO. N.Y.

This is a stationery letterhead of the Grand Rapids Chair Company from 1881, from about the same time as the preceding stereograph. Although the depiction of the buildings themselves is fairly accurate, the surroundings, including the nearby train crossing and a complete absence of other factories (features clearly designed to highlight the prominence of the company), is less so. Note the logs floating in the river in the distance, a nod to the involvement of the company's chief shareholder, Charles C. Comstock, in the lumbering business and an interesting preview of the logjam that occurred on the river a couple of years later. (Dilley.)

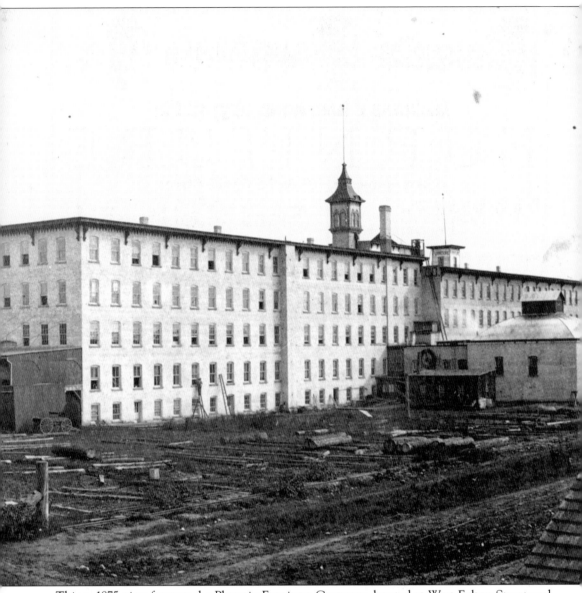

This *c.* 1875 view features the Phoenix Furniture Company, located at West Fulton Street and Summer Avenue. This factory was viewed as a model of progressive design when constructed between 1872 and 1875, and although taken down for the campus of Grand Valley State University in the early 1980s, portions of the workshops were preserved and installed in the furniture exhibits of the Public Museum of Grand Rapids, located nearby. Phoenix was one of the major furniture manufacturers of high-quality bedroom and parlor furniture of its time and employed young David Wolcott Kendall, the premier furniture designer of Grand Rapids furniture, in the 1880s. The company prospered under the management of its founder, William A. Berkey, until it was sold to the Robert W. Irwin Company in 1911. (GRPL.)

Phoenix Furniture Co.,

Manufacturers of Parlor, Bedroom, Library and Office

FURNITURE

Salesrooms, 71, 73 & 75 Canal Street,

W. A. BERKEY, President,
W. ADDIS, Vice President,
B. A. HARLAN, Secretary,
W. D. TOLFORD, Treasurer.

Grand Rapids, Mich.

Factory, West Side, Corner of Fulton and Summer Streets. Only Five Minutes Walk from Sweet's Hotel, Crossing Pearl Street Bridge.

This *c.* 1880 presentation card is from the Phoenix Furniture Company. Such cards, which preceded the appearance of the more colorful Victorian trade cards of the late 1880s and 1890s, were created to publicize business operations among salesmen and wholesale customers. (Dilley.)

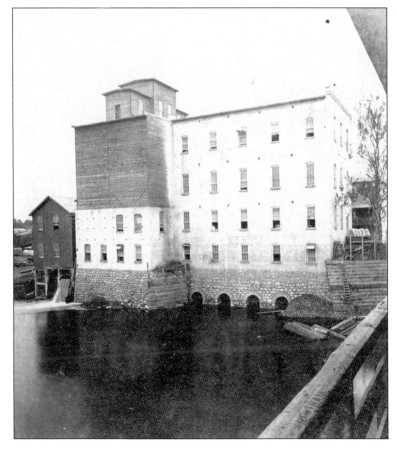

The Crescent Mills of the Voigt Milling Company, located at Pearl Street on the river, is seen around 1883, when the mill was first acquired by the Voigt Company. This building was destroyed in a fire in the early 1960s. The Voigt family was active in the flour milling business in Grand Rapids for many years, operating this and the Star Mills on the west side of the river, south of Bridge Street, well into the 20th century. (Baldwin/GRPL.)

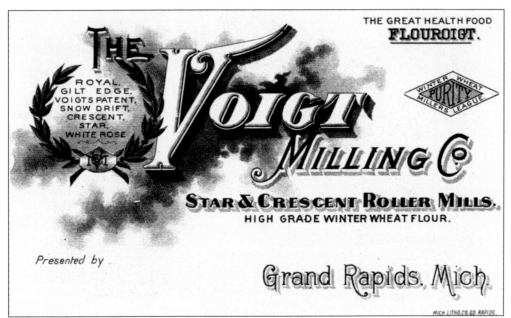

This *c.* 1885 presentation card is from the Voigt Milling Company. This card, touting the company's Star and Crescent Mills, was intended to be presented by a salesman calling on wholesale customers, as is indicated by the blank at the lower left, where the salesman's name would be inserted. (Dilley.)

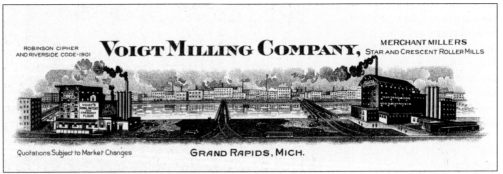

Here is a letterhead illustration of the Voigt Milling Company operation, showing both of the company's milling divisions. As is always true of such depictions, the most prominent feature of the picture is an idealized illustration of the company's factories, designed to demonstrate its capacity and prominence. (Dilley.)

This trade card is one of literally hundreds of different designs distributed by the Voigt Milling Company between 1880 and 1910 and passed out to retail buyers in an effort to promote the brand and to generate repeat business. Such cards, among the first fancy, colored images available, were often distributed freely by manufacturers and retailers to customers who were encouraged to collect them. (Dilley.)

In step with the fashion of the times, storefronts were rather elaborate in the 1870s, when this photograph was taken of the south side of Campau Square. Here the retail stores of Spring and Company, and Houseman and May are shown, both of them major retailers in Grand Rapids for decades before and after this view was produced. In the 1920s and 1930s, the buildings on this site were dramatically altered in appearance to accommodate new tenants, including a string of dime stores, which remained until the buildings were ultimately razed in the 1970s to allow the extension of Monroe Avenue through to Fulton Street. (Baldwin/GRPL.)

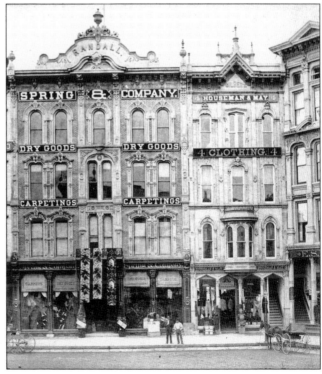

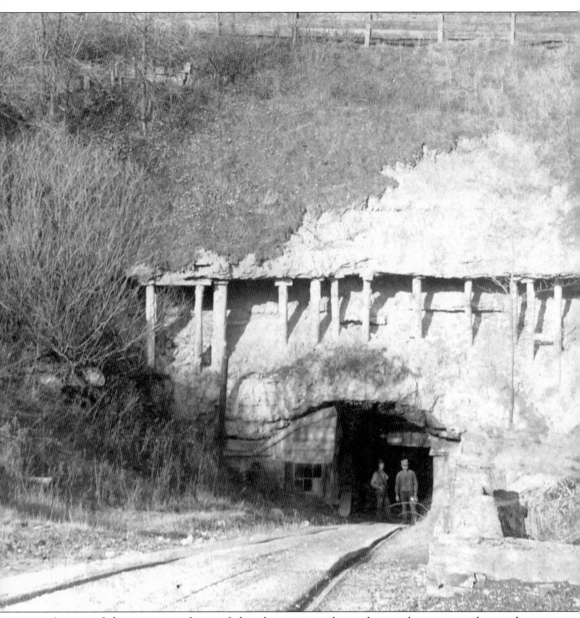

A view of the entrance of one of the plaster mines located near the river, at the southwest edge of Grand Rapids, is pictured here around 1880. From very early days, the abundance of extremely high-quality gypsum in broad veins on the both sides of the river south of the city attracted much attention and, eventually, investment to Grand Rapids. In the decades after the Civil War, when the use of plaster as a domestic building product had been firmly established, Grand Rapids became known as the plaster capital of the world, producing many tons of fine wall plaster, as well as stucco and other gypsum-based building products. The gypsum-plaster business and the mines from which the mineral was drawn continued through the 20th century at mills on Butterworth Avenue, south of downtown. (Walter/Dilley.)

This pair of trade cards was distributed by Spring and Company to promote its dry goods business in the 1880s. Such cards, often with images having nothing whatsoever to do with the nature of the business advertised, were actively collected, sometime in series, and were often pasted into albums at home. (Dilley.)

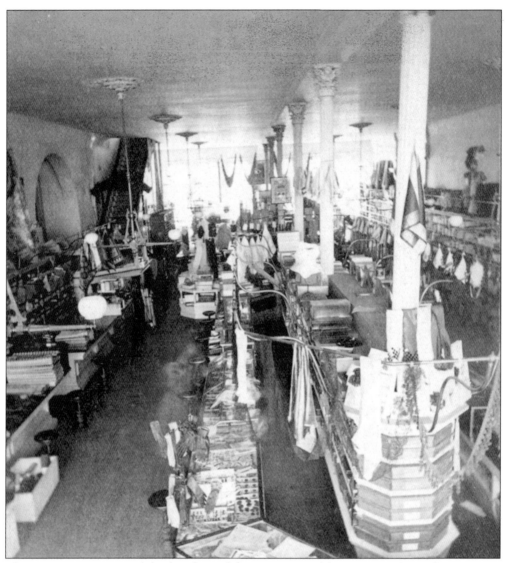

This is an interior view of the first floor of the Voigt Herpolsheimer store, located on Monroe Avenue, from about 1881. The partnership began in 1870, when Carl G. A. Voigt and William G. Herpolsheimer, both possessed of experience in dry goods retailing in other cities, joined together and opened a small dry goods store in Grand Rapids, selling primarily household goods and clothing. In 1886, the store was moved and greatly expanded at the corner of Ottawa Avenue and Monroe. In the late 1870s, the partners invested in flour milling and continued to operate both parts of the business together. In 1902, the business was divided, with Herpolsheimer taking the mercantile business and Voigt the flour mills. The Herpolsheimer store remained at the old location on Monroe until 1949, when it moved to a modern, newly constructed building at the corner of Division Avenue and Monroe. The store closed in the mid-1970s. (GRPL.)

This trade card is typical of many others that were distributed by retailers, such as the Voigt Herpolsheimer Company, beginning in the mid-1880s. Retailers were quite successful in creating a desire on the part of their customers for such cards, bringing them back into the store often to receive the latest issue. This card, with its card-within-a-card design, even suggests the manner in which many customers preserved their trade card collections, by pasting them in albums. (Dilley.)

Many of the trade cards that were distributed at this time contained no image, or even a suggestion of the goods being sold by the retailer, but rather offered only a pleasant, bucolic scene, which the retailer hoped his customer would find attractive enough to keep, thereby ensuring the continuing presence of the name of the store and perhaps inspiring the customer to return to receive more of such cards. (Dilley.)

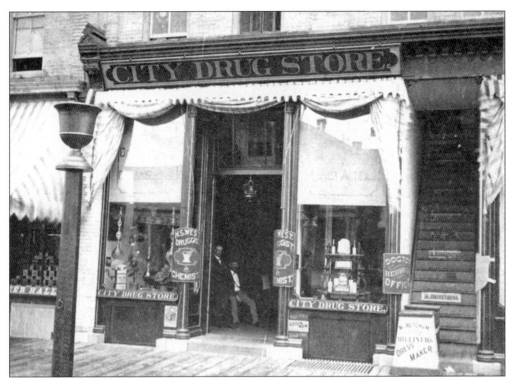

The City Drug Store, operated by one of the first druggists in the area, H. S. West, is pictured in 1882. The store was located on Monroe Avenue, at the corner of Ionia Avenue, and remained in operation at that location until the rebuilding of the present Morton House Hotel building in 1923. (GRPL.)

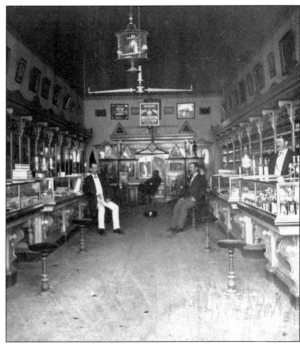

This is the interior of the City Drug Store, located on the ground floor of the original Morton House Hotel. (GRPL.)

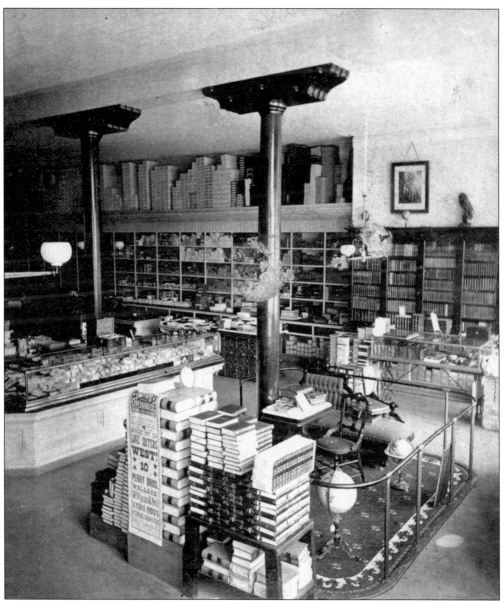

The interior of the Eaton and Lyon book and stationery store, located at the corner of Canal Street (lower Monroe Avenue) and Lyon Street, is shown in 1880. This firm was the major bookseller in Grand Rapids at this time and for many years before. In addition to books and periodicals, the store offered a full line of pens, blank books, and stationery supplies. The firm was also a major retailer of stereoviews, mostly produced by Schuyler Colfax Baldwin, who likely took this picture as well. (GRPL.)

These two trade cards were distributed by the Eaton and Lyon Company in about 1885. Given their shape, they may have been intended as bookmarks for the firm's book-buying customers. Although some of the trade cards that began flooding the community at this time were of rather crude design, some of the offerings, like these, were quite beautiful and illustrated the rapidly developing sophistication of the then new lithographic printing process. (Dilley.)

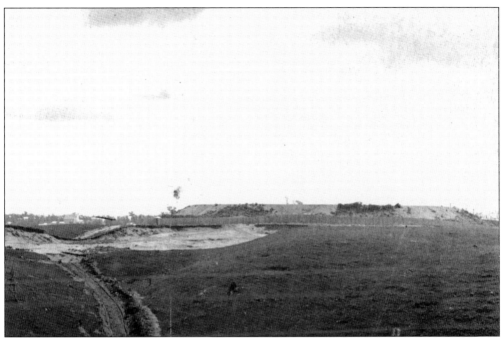

These two stereo cards, produced in the late 1870s, provide views of the City Water Reservoir, then located on the hill just north of downtown and to the east of Division Avenue. In the earliest days of the city, drinking water was simply drawn from the Grand River, surrounding creeks, and an occasional well, an arrangement that quickly became inadequate as the population grew. This reservoir was constructed in the mid-1870s for the collection of water from the Grand River, as well as Carrier, Coldbrook, and Lamberton Creeks in the city's north end, for use during the summer months when the seasonally slow-moving river was too polluted to offer a safe supply. (Baldwin/Dilley.)

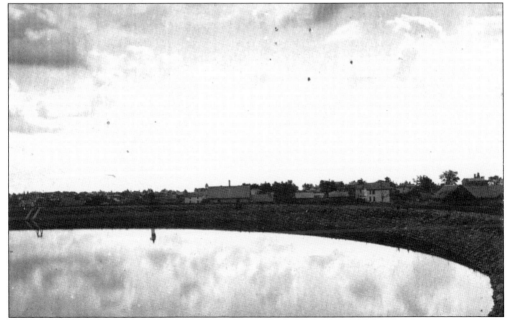

This is a rare stereograph of a group of performers from Redmond's Opera House, located near the river at the east end of the Bridge Street bridge, from about 1883. The photograph was taken on the stage of the opera house, which opened in the fall of 1882, with a piece of painted scenery as a backdrop. The handheld fans in the hands of three of the players probably disclose the name of the theater production but unfortunately are indecipherable. Beginning with Power's Opera House, located on Pearl Street between Monroe Avenue and Ottawa Avenue (which later became the Midtown Theater) in 1873, Grand Rapids enjoyed a thriving business in live, legitimate theater, as well as vaudeville entertainment until the arrival here of moving pictures in the mid-1920s. Big-name performers, the likes of Minnie Fisk, Lillian Russell, Ethel Barrymore, Otis Skinner, Spencer Tracy, and others, filled the Redmond Opera House, Smith's Opera House, and the Regent and Empress Theaters, as well as many other theaters during this period. (Barrows/Dilley.)

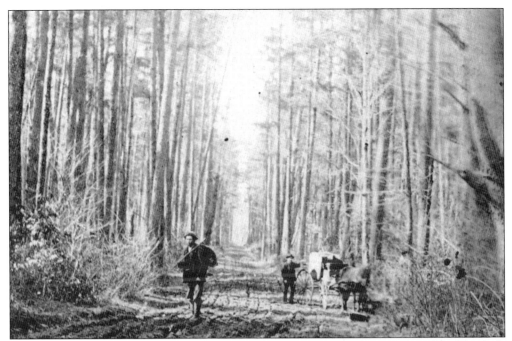

This is a commercial stereograph produced to illustrate the assets and operations of the Wonderly Lumbering Company, manufacturers of lumber, lath, and shingles, from about 1885. This view, titled "Road through the Lumbering Woods," is one of 22 views in a series that included images of the mills and products of the Wonderly Company and that were likely intended for use by company salesmen on their visits to prospective customers. (Hiler/Dilley.)

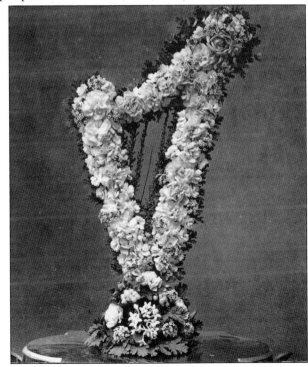

It seems that no business was immune to the power of showing its customers, in three-dimensional form, just what heights of sophistication the products they offered could attain. Here a floral arrangement, probably offered for funeral customers, is depicted, ready to show customers just what their money would buy. (GRPL.)

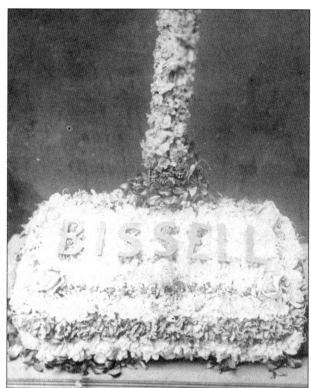

Here is another view of a floral arrangement, although it is hard to say whether this card was produced for the unknown florist or for the subject of the floral arrangement, the Bissell Carpet Sweeper Company. In any event, this floral artistry was recorded for posterity. (GRPL.)

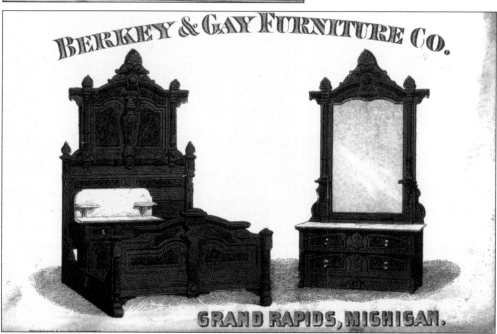

This is a trade card, from about 1880, produced for the largest furniture maker in Grand Rapids at the time, the Berkey and Gay Furniture Company. Depicted are examples of the Victorian Eastlake bedroom furniture that made the company famous and defined the look of Grand Rapids furniture for many years after. (Dilley.)

The greatest users of the stereographic form for commercial purposes in Grand Rapids were, not surprisingly, furniture manufacturers. Using these cards, a salesman in a location hundreds of miles away from Grand Rapids, with a stereoviewer and a box of cards, could allow customers to see for themselves what the products offered actually looked like rather than relying only on the salesman's pitch or a handful of line drawings. Although this use in sales was brief, its end hastened by remarkable advances in color lithographic printing, it was effective. Here is a view, from 1880, of the showroom of the Berkey and Gay Furniture Company. From a photograph like this, customers were given an idea of the size and prominence of the manufacturer and could, and did, select the Grand Rapids furniture found in homes and hotels all over the United States. (Baldwin/Dilley.)

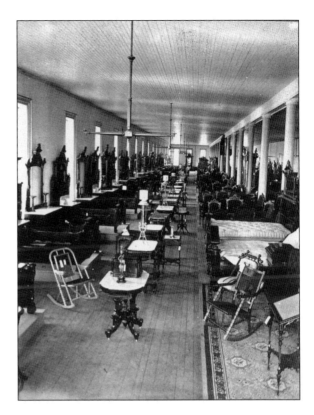

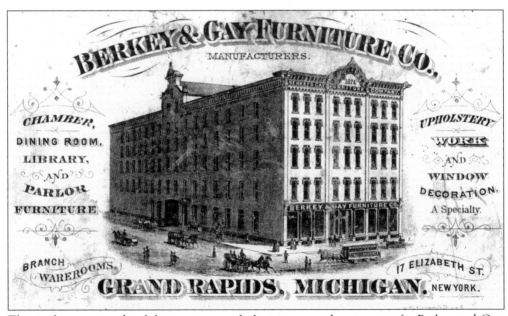

This is the reverse side of the previous card, depicting an advertisement for Berkey and Gay, including a picture of its warehouse on Canal Street. (Baldwin/Dilley.)

These views were produced on the occasion of the 100th furniture market in Grand Rapids, in January 1928. Representative of the 50 cards that made up the series, these views consist of furniture pieces offered in the semiannual market, placed in room settings in one or another of the dozens of furniture display buildings located around the downtown Grand Rapids area at this time. These views were produced quite late in the history of stereophotography but illustrate the value of such views in the commercial sale process. (Keystone/GRPL.)

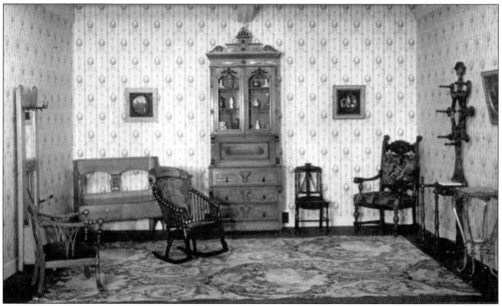

Five

THE RIVER RISES

Like many river cities around the country, Grand Rapids has suffered its share of floods and inundations. The first recorded flood in Grand Rapids occurred in 1832, only six years after the city's founding. Floods came in 1848, 1852, 1867, 1868, and many times thereafter, occurring, on average, about every five or six years. Most of the floods came in the spring, the result of the freeze-and-thaw cycle that comes at the end of Michigan winters, with the snow-melt high water of the river rising behind ice floes on the surface. The bridges spanning the river at Grand Rapids presented opportunities for the ice to jam the river's course further, resulting in the inundation of low-lying areas along the banks, primarily on the west side of the city. A few of these floods developed into full-blown catastrophes; during the flood of March 1852, the city allowed steamboats to dock at the intersection of Pearl Street and Monroe Avenue.

The greatest of the floods occurred in March 1904; the waters backed up behind a prodigious jam of pack ice in the river, reaching 20 feet, 5 inches—nearly six feet above the normal flood stage and still a record high. The rising waters quickly inundated the eastern banks and the entire west side, resulting in the closing of factories and loss of electric power for the entire city. Families were stranded, businesses could not operate—commerce in the city came to a complete standstill. Boats were brought over from Reeds Lake in East Grand Rapids for rescues, and shelters were set up to house the flood's cold refugees.

A number of efforts to break the ice jam were made: the tugboats *Doornbos* and *Gunderson* were brought upriver from Grand Haven to act as ice-breakers, and the city used dynamite on parts of the ice jam. These attempts went without noticeable effect. Ultimately the river itself solved the problem; with the pressure of the rising waters and the gradual dissipation of the ice, the jam eased and the waters subsided, leaving much damage and inspiring the construction of walls along the west river bank in the years that followed. In addition to setting a record high-water mark, the flood of 1904 was the most photographed flood in Grand Rapids. In addition to the stereographic images that follow, pictures of the flood-ravaged area appeared in postcards, cabinet photographs, and several commemorative booklets published in the years immediately following the memorable event.

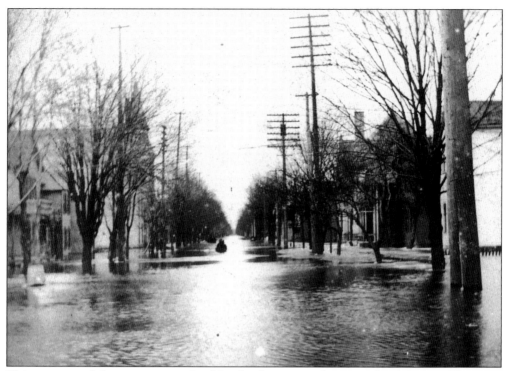

This is a view of the extensive reach of the floodwaters on the west side of the city. This view looks east on Leonard Street, from the intersection of Quarry Avenue. At the left is the West Leonard Fire Station. (Dilley.)

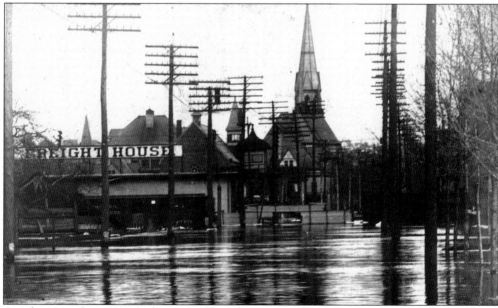

Another view from 1904 looks east on First Street, from Stocking Avenue. The neighborhood at the time, as is true today, consisted of many businesses, both large and small, as well as the homes of those who worked and patronized those businesses. All of these residents suffered from the inundation and the freezing and thawing that occurred in the weeks afterward. (Dilley.)

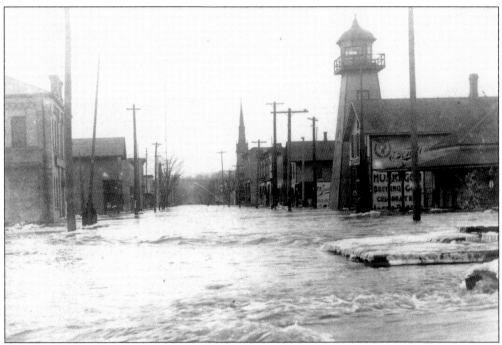

The floodwaters of the 1904 flood reached well inland, away from the western bank of the river. Here is a view looking west on Bridge Street, past the light signal tower of the railroad crossing at the right, and beyond. The spire of St. Mary's Church is visible in the distance. (Dilley.)

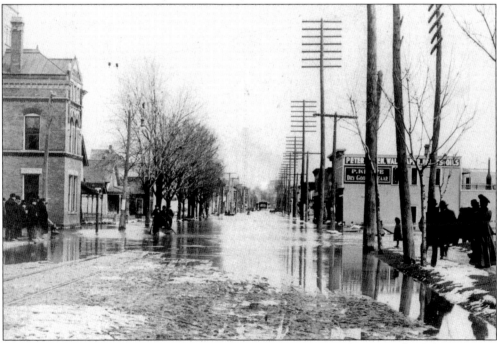

This is another view of the extensive reach of the floodwaters on the west side of the city. This view looks east on Leonard Street from the intersection of Quarry Avenue. At the left is the West Leonard Fire Station. (Dilley.)

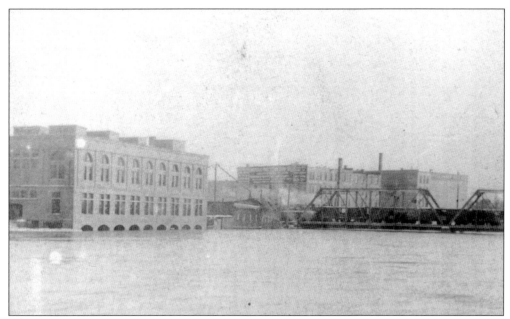

Another view shows the high water level on the east side of the river, looking south from the Pearl Street Bridge. The building at the left center is the Citizen's Telephone Exchange, the main switchboard for one of the two companies then providing telephone service in the city. Unwisely located at the river's edge, the operation was flooded out in the inundation of 1904. (Dilley.)

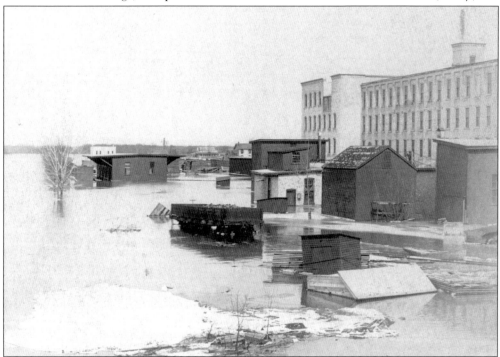

Factories located on both sides of the river were affected by the rising waters. Pictured here, the factory of the Grand Rapids Chair Company, located on Monroe Avenue, north of downtown, was temporarily closed as the result of the flood. (Dilley.)

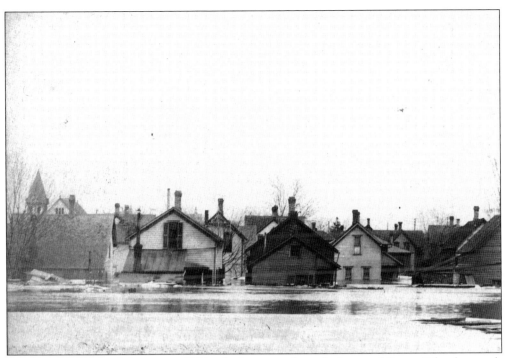

This view of the flood damage in 1904 is looking east from the Leonard Street School grounds toward the river. Here the floodwaters were three to four feet in depth. (Dilley.)

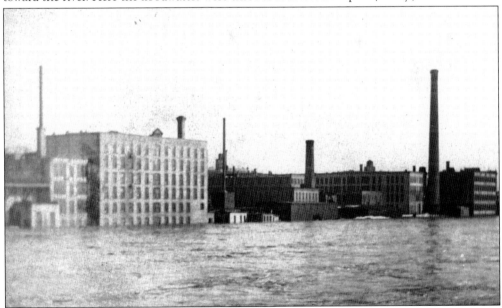

As has been suggested, not all the damage from the 1904 flood was confined to the west side of the river. The lower parts of the east side at the river's edge, filled primarily with factory buildings, were also affected. Here is a view, taken from the western edge of the Bridge Street bridge, looking southeast, showing the flooding that occurred near the heart of the downtown area. The large factory building at the left is the Bissell Carpet Sweeper Company, the present site of the convention center. (Dilley.)

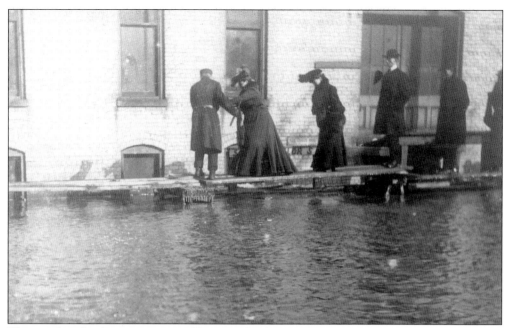

The standing floodwaters were, in addition to the damage done to homes and businesses, a major inconvenience, making even moving about most of the west side of the city nearly impossible. Here residents at Front and Pearl Streets make use of the temporary "elevated" walkway, which remained in place until the flood receded. (Dilley.)

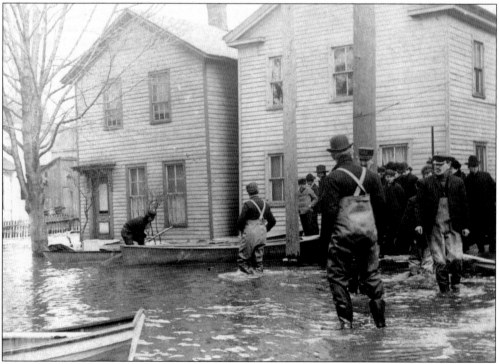

A temporary aid station for victims of the flood was opened on Broadway Avenue, normally well away from the reach of the river waters, but obviously not distant enough. (Dilley.)

Six

A BAD DAY IN JULY 1883

As the upper Midwest was settled, demand for lumber escalated, and the pine and hardwood forests of Michigan were tapped to fill this need. Cut logs were transported to sawmills on the river for finishing. While most of the big operations in Michigan were located well north of Grand Rapids, there was logging in the Grand River Valley, northeast of Grand Rapids, feeding the sawmills and fledgling furniture operations on the banks of the Grand River.

Lumberers spent much of the fall and winter in the forests, and they hauled cut logs to the banks of the rivers, where they accumulated in great piles, to be tumbled into the stream when the spring thaw caused otherwise peaceful waters to rise. Closer to the milling destination, the logs were sorted by ownership, and corralled into huge floating pens called booms. In the months preceding July 26, 1883, western Michigan had been unusually rainy. By the end of July, these conditions had created near-crisis conditions on the river west of the city, where logs awaiting milling in Grand Haven had nearly been swept into Lake Michigan by the river. Disaster was averted, but the difficulties were not over. Hundreds of thousands of logs, thought to be safely "penned" above Grand Rapids on the Grand River were dangerously close to violently cascading downriver. The heavy rains continued, and on July 26, 1883, the fear became a reality, when several waves of logs broke free—probably in excess of 100,000,000 feet of cut timber—and came thundering into Grand Rapids on the river highway in a mass more than seven miles in length. When the jam occurred, it reached a depth of 30 feet and flooded both sides of the river, inflicting serious damage to structures on the banks. Three railroad bridges upstream and downstream of downtown were swept away by the rushing logs "as man might [destroy] a child's castle of cards." A section of one bridge collided with another, which "melted away as though it had been a shadow through which the first bridge was passing."

The logjam and its aftermath were popular subjects of local stereophotographers, who captured many dramatic scenes, some of which are presented here.

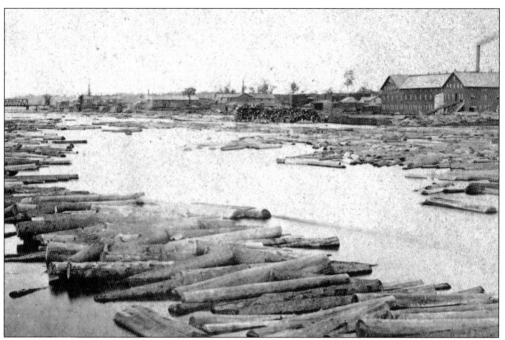

This is a view, taken in the years just before the logjam and flood of 1883, from the Leonard Street bridge. At this time, a modest lumbering activity was in operation in Grand Rapids, evinced by the sawmills located on the eastern bank of the Grand River, to the right. Most of the lumber milling in Grand Rapids at this time was directed at providing the growing furniture manufacturers with the hardwoods they needed for their products. (Baldwin/Dilley.)

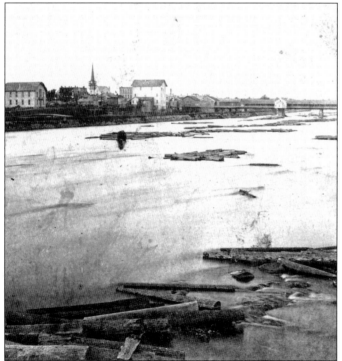

The Grand River is seen here, with enough cut logs snagged on its banks to suggest the use of the river as a transport highway for logging operation farther north and east. The view here is from the eastern side of the Bridge Street bridge, looking across the river to the mills and factories then developing on the west side. The date of the photograph is 1880. (Baldwin/Dilley.)

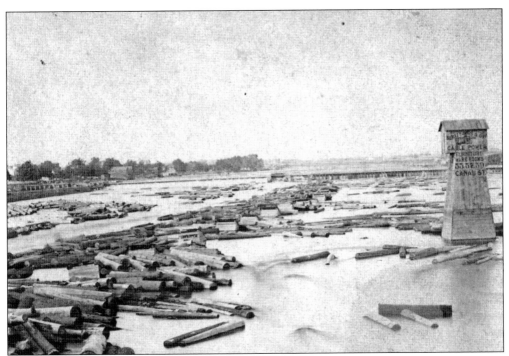

As the logs floated downriver and into Grand Rapids, they were sorted, making use of a series of floating booms not unlike corrals, and then were either milled locally or sent farther downriver to sawmills at Grand Haven. The mid-river tower at the right was constructed by the Berkey and Gay Furniture Company, whose factory was located on the east bank of the river, just off the right side of the picture, to elevate a power cable above the turmoil of the passing logs. (Baldwin/Dilley.)

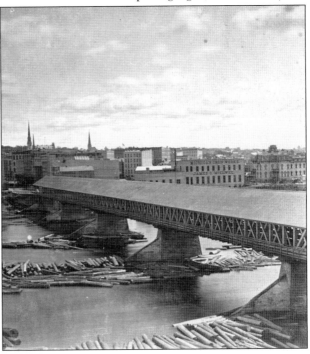

This view of the original Pearl Street bridge was taken in about 1875 from the western shore of the river, looking east toward downtown. The bridge was built by a private company, the Pearl Street Bridge Company, and was operated as a toll bridge from the time of its construction until 1873, when it and the bridges at Leonard and Bridge Streets, of similar construction, were purchased by the city. Visible in the river are the sorted logs, awaiting milling or further transport downriver. (GRPL.)

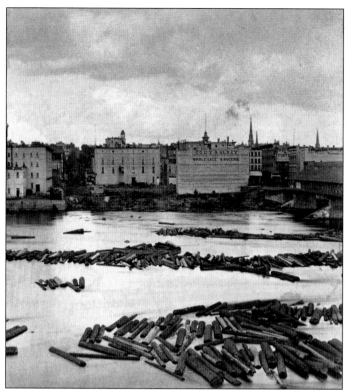

This is another view of the east bank of the river, taken from the west side at about the same time as the previous view. At this time much of the eastern riverbank in the downtown area was filled with mills and factories. At the center of the picture, on the far bank of the river, is the present site of the Grand Plaza Hotel. Logs awaiting milling are again visible in the river. (Baldwin/GRPL.)

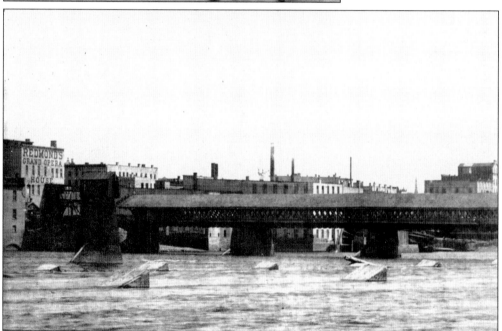

In this view, from July 1883, the Bridge Street bridge is shown, with the downtown area behind. At the left edge of the photograph is the Redmond Opera House, which on that date was headlining Thatcher, Primrose and West's *Mammoth Minstrels* show. Here the high and rapid water level, which gave rise to the logjam and flood, is visible. (Barrow/Dilley.)

The logjam on the Grand River, which developed rapidly as the torrent of logs came down the river into Grand Rapids on July 25 and 26, 1883, is here visible as it piled up against the Detroit, Grand Haven and Milwaukee Railroad bridge at the southern end of the downtown area. (Jackson/Dilley.)

A closer view of the jam at the Detroit, Grand Haven and Milwaukee Railroad bridge, taken from the west bank of the river on July 26, 1883, shows the area just before the bridge gave way. (Barrow/Dilley.)

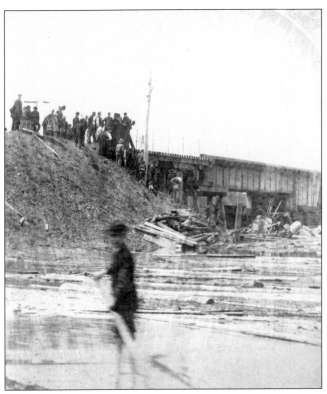

It was on the morning of July 26, 1883, that the massive logjam, held back by the iron span of the Detroit, Grand Haven and Milwaukee Railroad bridge, finally broke and swept the bridge away, taking part of the span with it and leaving the remnants that are visible in this picture. (Barrows/Dilley.)

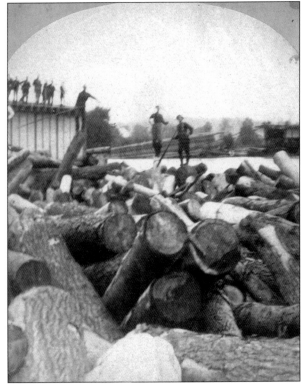

This view shows the Detroit, Grand Haven and Milwaukee Railroad bridge after its failure. Here, as in the previous view, are visible some of the river men, who, over the days that followed the logjam, strove to recover some of the logs cast up on the banks of the river. (Barrows/Dilley.)

98

This view features the mass of logs as it proceeded downriver from Grand Rapids, carrying with it, at least for the moment, a section of one of the three railroad trestles taken out by the massive jam and flood. (Dilley.)

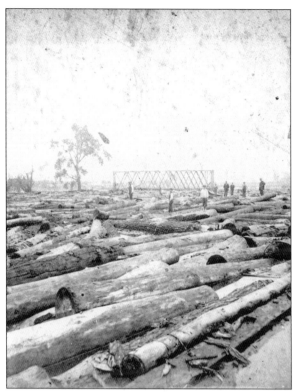

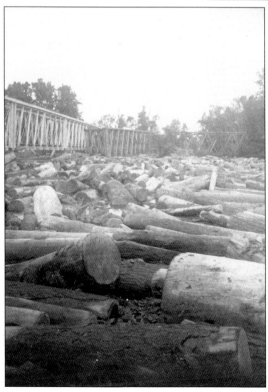

The railroad bridge of the Lake Shore and Muskegon Railroad, at Grand Rapids, was also wrecked and actually carried away by the logs on the high waters of the Grand River on July 26, 1883. (GRPL.)

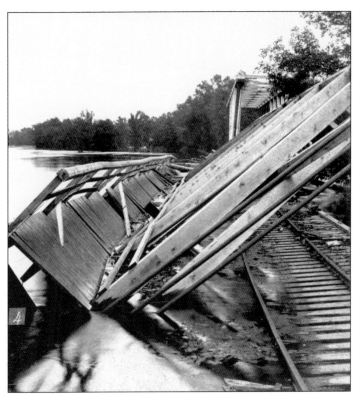

Another of the dramatic casualties of the logjam, the bridge of the Chicago and West Michigan Railroad, which crossed the Grand River south of downtown, was obviously torn to pieces by the rushing force of the logjam. (GRPL.)

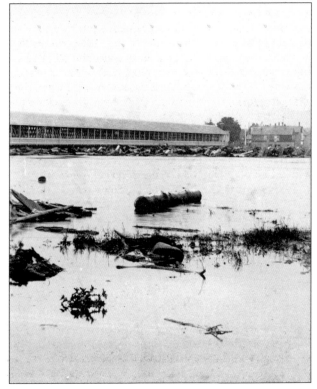

This is another view of the aftermath of the jam and flood. Here a photograph of the Leonard Street bridge, taken from the east side of the river looking west, shows some of the stray logs that then littered the river's edge. This bridge, one of three covered traffic bridges over the Grand River within the city, was not seriously damaged or weakened by the logjam but was soon thereafter replaced with a more modern span. (Barrows/Dilley.)

Seven

LIFE WAS NOT ALL WORK

The first park to appear in Grand Rapids was Fulton Street Park, now known as Veteran's Memorial Park, located just east of the intersection of Fulton Street and Monroe Avenue. There is some controversy over exactly by whom the land was deeded to the city for park purposes, it having come either from Samuel Dexter or Louis Campau (or perhaps both), both pioneer residents. Initially the park was viewed as a fairly typical town square, located in what was then thought to be close to the center of the little town. In 1838, a small single-story frame building was built there to house the county court and all other county governmental functions. After this original building was lost, along with all its contents, in a fire in 1844, a second structure was built on the square but was vacated in 1852 when the business of the court and the county were moved to larger quarters farther downtown, closer to the river.

During the Civil War years, the park hosted a steady variety of patriotic rallies, speeches, and bonfires, much to the annoyance of surrounding residents. It was largely through the efforts of a single man, Thomas D. Gilbert, a local banker possessed of strong civic goals for his city, that the dusty, weed-filled square began to become a real park. Grateful citizens later installed a bronze bust of Gilbert on the north side of the park.

By the start of the 20th century, Fulton Street Park had come into its own; its centerpiece was the ornate cast-iron fountain installed in the 1880s. Following World War I, the first pylons bearing the names of local men lost in the war were erected, replacing the original fountain. The same impulse returned after World War II but was stalled by funding problems. Finally, after the close of the Korean War, in 1957, the park was rededicated as Veteran's Memorial Park and today houses a memorial to all war veteran from Kent County.

The other grand space in Grand Rapids is John Ball Park, located at the western terminus of Fulton Street and Lake Michigan Drive. The land that forms the heart of the park was bequeathed to the city by one of its earliest pioneers, John Ball, upon his death in 1884. City alderman Thomas D. Gilbert recognized the value of the large parcel of unique property, which remains the largest public park in the city.

This view of Fulton Street Park from about 1870 looks northeast across the intersection of Monroe Avenue and Fulton Street. In the foreground is one of a small fleet of horse-drawn streetcars that had been put into service in Grand Rapids only a couple of years before. The park is shown encircled by the picket fence installed by Thomas D. Gilbert. The trees planted by Gilbert have not yet reached maturity. At the center of the park is a bandstand, later replaced by an ornate cast-iron fountain, and still later by the veteran's memorial that remains today. In the center distance is First (Park) Congregational Church, built in 1868, showing its steeple at full height. In the distance to the left is the original high school building in Grand Rapids, on the site now occupied by parts of Grand Rapids Community College. (Baldwin/Dilley.)

Dating from about 1880, this view is of the elaborate cast-iron fountain that adorned Fulton Street Park from about 1880 until it was replaced by the first version of the veteran's memorial in 1926. (Walter/Dilley.)

This view shows one of many garden arrangements installed in the 1880s and 1890s at John Ball Park, at a time when formal landscaping and planting was very much in vogue in urban gardens. Many of the seasonal plants that were used in these displays were grown for this purpose in the greenhouses, which were also part of the operation at the park. (Walter/Dilley.)

In another view of the formal plantings found at John Ball Park in the 1890s, the beautiful wooded heights of the hills bequeathed to the city by John Ball are visible. (Walter/Dilley.)

This view of the grotto at John Ball Park, actually the outcropping of a natural spring on the eastern side of a hillside near the present entrance to the zoological garden, is from about 1890. This site, where visitors could step into the shade of the artificially created grotto shelter and partake of the cool, naturally flowing springwater, was much visited and photographed at the time. (Walter/Dilley.)

Here, in a comparatively late stereoview, is an arch originally constructed for a Michigan pavilion at the 1893 World's Columbian Exposition in Chicago. It was reconstructed in John Ball Park after the fair's closing. The arch was constructed of a variety of Michigan stones, for the purpose of extolling the virtues of building materials from the state. In the years following this photograph, a cannon captured during the Spanish-American War was placed in the area in front of the arch, a gift to the city from Pres. William McKinley. (Walter/Dilley.)

Probably the earliest human residents of the Grand River valley were the Hopewells, who lived along the Grand River roughly 2,000 years ago. Little is known of the local Hopewell culture except what has been gleaned from the excavation of some of the burial mounds found in an area to the southwest of the city, along the river, producing some artifacts that have found their way into the collection of the Public Museum of Grand Rapids. This is a view of that burial site from about 1880. Largely ignored during much of its later history, the site has since been appreciated sufficiently as an archaeological and sacred burial site to ensure its protection. (Baldwin/GRPL.)

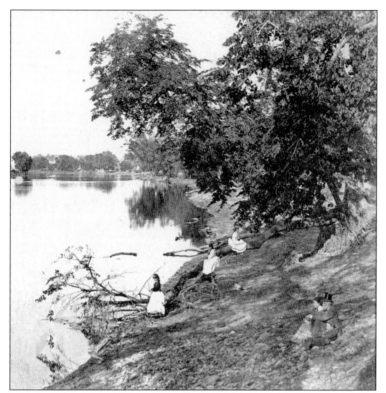

This is a view of an unknown location along the Grand River in the Grand Rapids area, being enjoyed by members of the Samuel Graves family in about 1875. Outings of this sort were a common form of recreation at that time, and the almost completely undisturbed banks of the Grand River provided an ideal spot. (Baldwin/Dilley.)

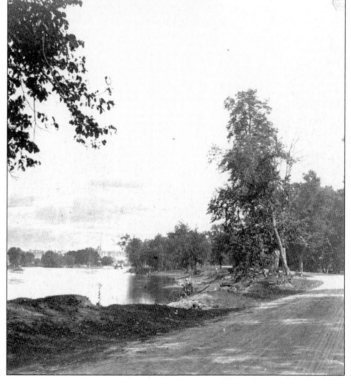

This view was taken at the southern edge of the Grand River, southwest of the city, in about 1875. This land, which was to become fully industrial in the following years, was at this time still largely untouched. At the left of the photograph, in the distance, is the small, but developing, skyline of the city. (Baldwin/GRPL.)

This is a rather curiously disorganized view of natural history specimens at the Kent Scientific Museum, the predecessor of the Public Museum of Grand Rapids, from about 1880. Before the museum found a home of its own in 1903, its archaeological and natural history collections, consisting largely of preserved animal specimens and Native American artifacts donated by interested locals, accumulated and were transferred to and from a number of locations around the city. Here they are displayed in a room of the old Central High School, located on the hill above the eastern side of the city. (GRPL.)

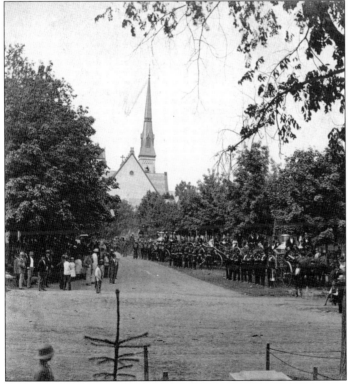

As has been mentioned, parades abounded in the early life of the city of Grand Rapids. Here is the beginning (or end) of such an occasion, photographed at the edge of Fulton Street Park in the mid-1890s. The participants in the parade are local firefighters. In the background is the Fountain Street Church, a building that was, notwithstanding the best efforts of some of those who marched in the parade, destroyed by fire some 20 years later. (Baldwin/GRPL.)

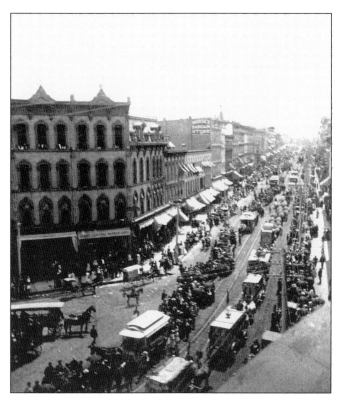

Some of the parades that occurred in early Grand Rapids were more exotic than others, and that shown in this and the following view would rank among the most unusual. Shown here is a circus parade, after its arrival at union station on South Ionia Avenue, proceeding west down Monroe Avenue into Campau Square in about 1885. The building at the left was replaced a few years after this photograph by the Wonderly Block, which was in turn replaced between 1917 and 1927 by the present McKay Tower. (GRPL.)

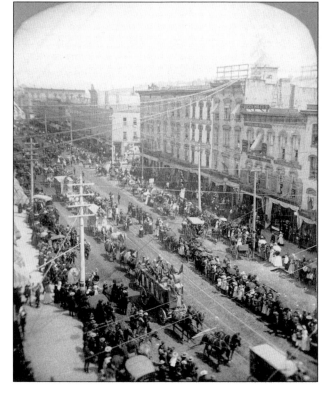

This is another view of the circus parade from 1885, this time having passed through Campau Square, here proceeding north on Canal Street (now lower Monroe Avenue). Although the parade was probably at least somewhat spontaneous, the crowds of people all along the route are large, probably presaging a good level of attendance at the circus performance at the fairgrounds north of downtown. (GRPL.)

Eight

EAST OF TOWN

Beginning in the 1830s, as the very earliest nonnative settlement on the Grand River was taking place, early farming settlement was also beginning on the land to the east of the future city of Grand Rapids. In 1833, Porter and Polly Reed, arriving from upstate New York, established a small farm on the land just west of what was to become known as Reeds Lake. This farm, the first in that area, along with the Reed family, eventually gave birth to the village, and later the city of East Grand Rapids. In the half century that followed its birth, East Grand Rapids became a mecca for vacationers and fun-seekers from miles around, as its principal feature, Reeds Lake, became known and was developed.

At first simply a scene of bucolic open space at the lake shore, East Grand Rapids later became a recreation destination. About 1880, modest development along the shores of the lake began, and beginning in 1897, the Grand Rapids Street Railway Company undertook a development process in earnest, opening first a park area that was heavily visited and then over the succeeding years, a full-scale amusement park called Ramona, complete with roller coaster, midway, and fun house, as well as boat liveries and a series of steam-powered excursion boats that offered cooling rides around the lake all summer long. A variety of other attractions soon opened, including a vaudeville performance theater that opened in the early 1900s and attracted many big names in entertainment, including Edgar Bergen and the Marx Brothers. Later a dance pavilion was added to host big band entertainers.

In 1886, a group of young businessmen from Grand Rapids founded the O-Wash-Ta-Nong Club (its name taken from the Ottawa name for the rapids on the Grand River where the city was founded). The club built a large boathouse on the western bank of Reeds Lake that became the focal point of parties and social events. This club was soon joined, and later succeeded by, the Phoenix Club nearby and the Lakeside Club.

All of this pleasure-seeking activity at Ramona continued, largely unabated, for the next 50 years, through two world wars and the major cultural changes that came with them, until by the early 1950s, when the impact of television and the automobile were felt, making the old park much less an attraction than it had been previously. With much nostalgic regret, the park was closed in the early 1950s.

This is an early view of the Reeds Lake area, probably about 1880, on either the north or south shore of the lake, which shows the bucolic, parklike quality of the area before the extensive amusement development that came a few years later. (Baldwin/Dilley.)

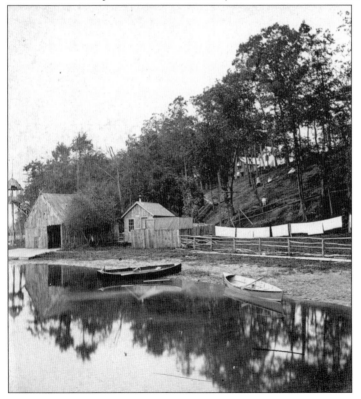

This pre-Ramona view shows the southeastern shore of Reeds Lake at an area known as the Pioneer Club, an early group of very rustic vacation cottages and retreats. After the beginning of the 20th century, this area was completely redeveloped into one of the most prestigious residential neighborhoods in the area. (Baldwin/Dilley.)

Miller's Landing, on the south shore of Reeds Lake, attracted revelers of many descriptions and intentions, both to partake of the generally unpoliced atmosphere and, on occasion, for Sunday school picnics and outings. (GRPL.)

The clubhouse of the O-Wash-Ta-Nong Club, located on the west shore of the lake where Collins Park is today, was the first of several private social clubs to locate at Ramona. This clubhouse was put up in the late 1880s, but the club failed in 1892, and this building was razed. A few years later, the Lakeside Club was founded and built a new clubhouse on the same site. That building was lost in a fire in 1904, and although rebuilt, never prospered thereafter and ultimately burned again, after it had been briefly taken over by a reformed O-Wash-Ta-Nong Club in 1918. (Baldwin/GRPL.)

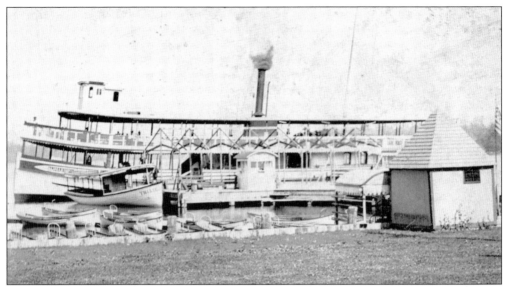

This view of the steamship *Major A. B. Watson* was taken in 1891, the first year that excursion ships began to ply the waters of Reeds Lake. The ship, named for local lumberman and Civil War hero Amasa B. Watson, was 130 feet in length and could carry 460 passengers. Here it is shown at its dock at Ramona, on the western shore of the lake. The smaller steam launch in the foreground, the *Trixie*, like many others of its type, was available for smaller parties. The *Major A. B. Watson* was one of three excursion ships that worked the lake over the years, including the smaller ships the *Hazel A.* and the *Ramona*. (Walter/Dilley.)

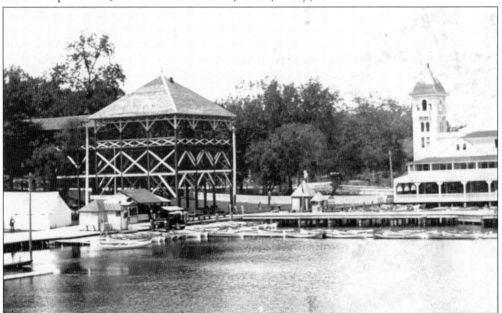

This is a view from about 1893 of the boat livery docks and the newly constructed Lakeside Club building, on the site of the former O-Wash-Ta-Nong Club on the western shore of Reeds Lake. The photograph was likely taken from the deck of the *Major A. B. Watson* on a day at the beginning of the summer season, when the bustling crowds that always filled the area in season had not yet arrived. (Walter/Dilley.)

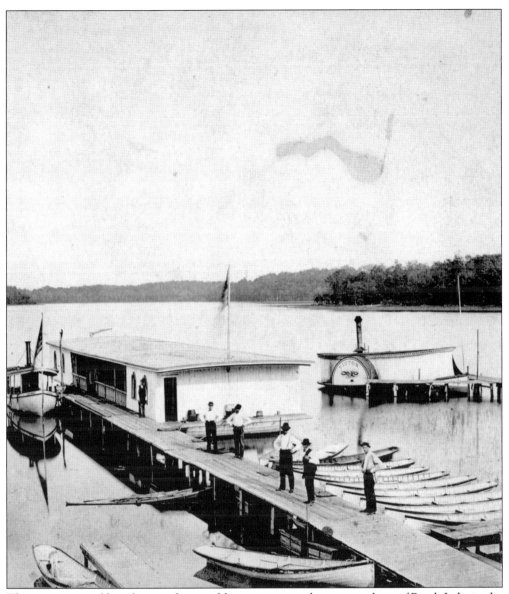

There were several boat liveries that quickly sprang up on the western shore of Reeds Lake in the mid-1880s, when this photograph was taken, as crowds grew and the popularity of the Ramona area became apparent. This view is from the western shore of Reeds Lake, at about where the Grand Rapids Yacht Club is today, looking to the southeast. Shown here before the arrival of the excursion boats five or six years later, the large boat to the right in the photograph is a barge known as the *Crook's Barge*, an unpowered craft that, when loaded with passengers (and musicians for dancing), would be towed out into the lake by one of the steam launches, like the one at the extreme left of the picture. (Walter/GRPL.)

Miller's Boat Livery was one of the several busy and popular operations located on the western shore of Reeds Lake, adjacent to the Ramona park in 1885. These small boats would be rented by visitors for rowing on the lake or to travel the canal-like pathways dug for this purpose through the forested area at the northwestern shore of the lake. In the background, the clubhouse of the O-Wash-Ta-Nong Club is visible. (Walter/GRPL.)

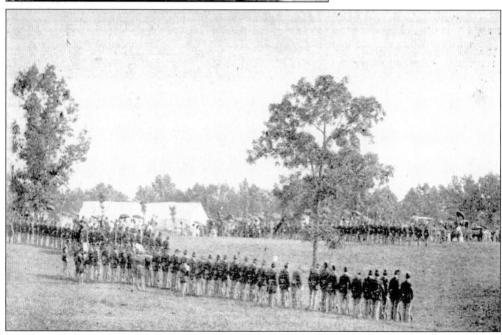

In August 1876, probably at the tail end of the extensive centennial celebration in the area, the 2nd Regiment of the Michigan State Guard visited the Reeds Lake area from Fort Custer. Here it is in parade formation on one of the fields west of Reeds Lake, on which, in the coming decade, the Ramona park would spring to life. (Moulton/GRPL.)

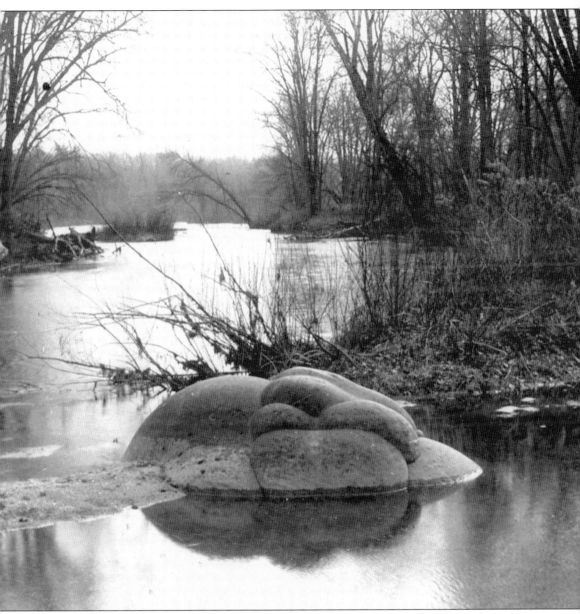

Turtle Rock, probably a then well-known spot on the Thornapple River (located in Cascade in eastern Kent County), is pictured here in about 1880. This view is the work of C. E. Walter, a stereophotographer based in Casade who is responsible for most of the stereographic views that survive from the areas east of Grand Rapids, including East Grand Rapids and Ramona. Walter advertised himself (on the back of each stereograph) as providing "Stereoscopic views and Tranparencies, Negative, Stereo and Single, made to order in any part of the world." (Walter/Dilley.)

Taken in about 1907, this view features the newly completed manor house at Holmdene, the suburban estate of Edward Lowe and Susan Blodgett Lowe, located east of the city between Fulton Street and Robinson Road. The house is one of several buildings on the estate, all built in the Tudor Revival style. The Lowes were major benefactors of Butterworth (now Spectrum) Hospital, named for Edward Lowe's uncle, its original benefactor. In 1945, the estate was acquired by Aquinas College, which maintains its campus here still. The manor house has been put to a number of uses over the years. It presently serves as the administration building of the college. (Dilley.)

Nine

THE 1876 CENTENNIAL CELEBRATION

In 1876, as the 100th anniversary of the founding of the nation approached, a consciousness of the importance of the date and an interest in commemorating it seems to have been nearly universal. Citizens of many cities and towns were well aware of the approach of the anniversary and wanted very much to participate in its proper celebration. In this, Grand Rapids was no different than other growing communities, and its citizens eagerly seized the opportunity to express their patriotic fervor.

In the opening weeks of 1876, formal proposals for a fitting centennial observance were presented to the city fathers, who eagerly began the planning of a comprehensive, all-inclusive event for the coming Fourth of July. Committees were appointed, funds were raised, and celebratory events were planned. The focus of the celebration seems to have taken two forms. First, there would be many grand and commemorative decorations placed around the city. Businesses in the downtown area were generally encouraged to deck out their locations in patriotic style, and many of them seem to have risen to unprecedented heights in their use of bunting, crepe, and evergreen decoration. The city itself planned and erected a grand patriotic arch, some 60 feet wide and 50 feet high, in Campau Square. Other, more diminutive archways were placed at four other locations around the city.

Second, a grand and impressive processional parade was planned for the Fourth of July. The marching route was planned to run from the center of the city at Campau Square, over to the west side of the river, and then back to the east side, where it coiled around the downtown area, finally ending at Fulton Street Park, where speeches and music were provided. Many veterans of the Civil War redonned their uniforms for the procession and were joined by floats that exhibited some of the industries then developing in the city. The attendance at all the day's events was immense. The celebratory day was completed by a large traditional display of fireworks.

It will doubtless be noted that the stereo images that follow do not all depict the huge crowds described for the centennial event, or what must have been the very considerable activity that occurred that day. Such moving crowds, and the grand parade itself, would have appeared in these early photographic images only as a blur, so the attention of the photographers was more often directed at the commemorative decorations themselves.

This view is from the (then) intersection of Commerce Street and Monroe Avenue, looking west toward Campau Square in the course of the day. Halfway down the street on the right is the Morton House Hotel. A close look at the confused center of the picture will reveal the small arch at the corner of Ottawa Avenue, as well as the grand arch located in Campau Square. (Baldwin/Moulton/Dilley.)

This is the title page of a book published by local publishers, Loomis and Dillenback, in conjunction with Grand Rapids' celebration of the centennial of American independence, in 1876. The firm had a float in the grand parade on which a printing press was operating, actually producing the pages of the commemorative book. (Dilley.)

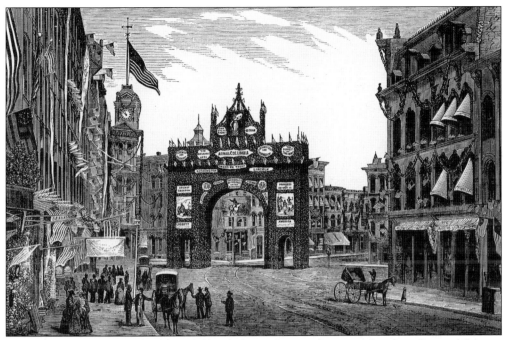

This line drawing from the centennial book shows the grand memorial arch at Campau Square. Behind the arch is Sweet's Hotel. (Dilley.)

This drawing from the centennial book shows the West Street bridge, looking west from the bridge. It shows the district rebuilt after the great fire of June 19, 1875. (Dilley.)

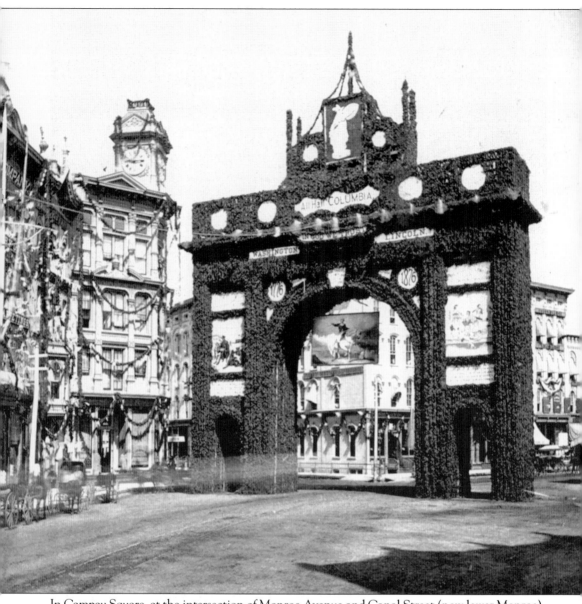

In Campau Square, at the intersection of Monroe Avenue and Canal Street (now lower Monroe), the grandest of commemorative monuments was constructed for the centennial celebration. The grand arch, designed and constructed by a local architect/builder, stood 60 feet high and was 12 feet thick and 50 feet wide. The arch was of strong, though temporary, construction, intended to stand for only a short while before and after the actual Fourth of July celebration, and was thickly covered with evergreens and over a dozen specially executed patriotic portraits and allegorical paintings. The tower to the left of the arch is the E. S. Pierce Block, known as the Tower Clock Building, housing the E. S. Pierce clothing store and completed only the year before. Beyond the arch is Sweet's Hotel, both buildings located on the corners of Pearl Street. (Horton/GRPL.)

This drawing, also from the centennial book, shows how present-day Campau Square looked in 1832. The highly idealized view looks west across the Campau Square site and the Grand River to the west bank. (Dilley.)

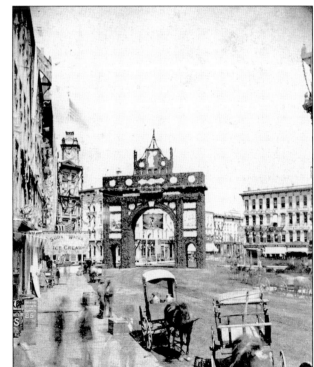

Another view of the grand arch, this was taken from the corner of Market Street and Monroe Avenue. At the extreme left edge of the photograph is the front of the Rathbun House Hotel, and at the right, at the corner of Pearl Street and Monroe Avenue, is the Lovett Block, which still stands, although much altered. (Horton/GRPL.)

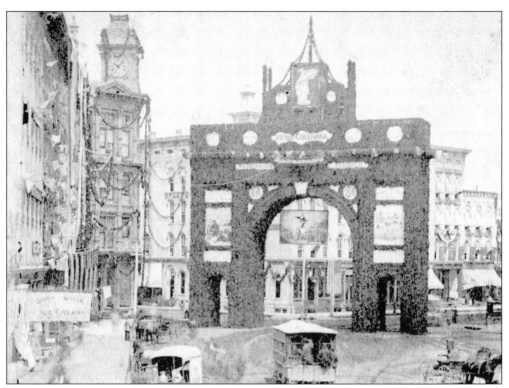

Here is yet another view of the grand arch, taken from a short distance up Monroe Avenue and showing the approach of a horse-drawn streetcar, which would pass under the center of the arch. (GRPL.)

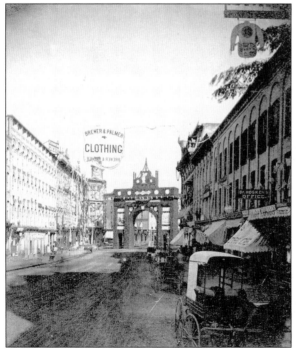

It seems that some local entrepreneurs found the promise of large crowds for the centennial festivities too great a temptation to resist in the placement of their advertising. This large elevated sign, hung on a cable spanning Monroe Avenue just east of the grand arch, advertises a local clothing store. (Horton/GRPL.)

Several less monumental commemorative archways were also constructed at various places around the downtown area. This triple arch, which spanned the width of the street, was erected at the corner of Canal Street and Bronson Street (now Crescent Street, which then intersected with Canal) along the grand parade route. (Moulton/GRPL.)

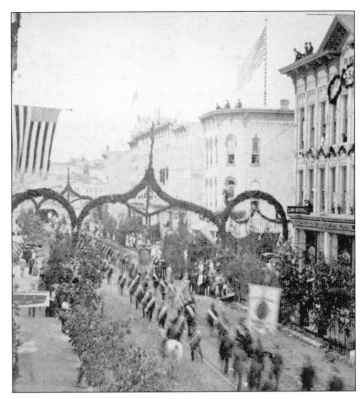

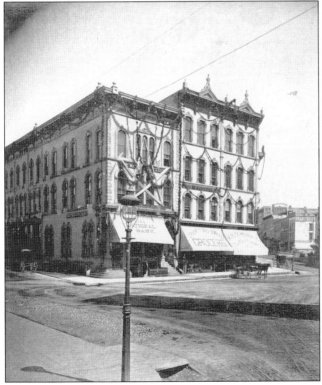

These buildings, on the site of the present McKay Tower at Campau Square, show the decoration of buildings in downtown Grand Rapids that was typical for the centennial occasion. To the left is Pearl Street and to the right is Monroe Avenue. (Horton/GRPL.)

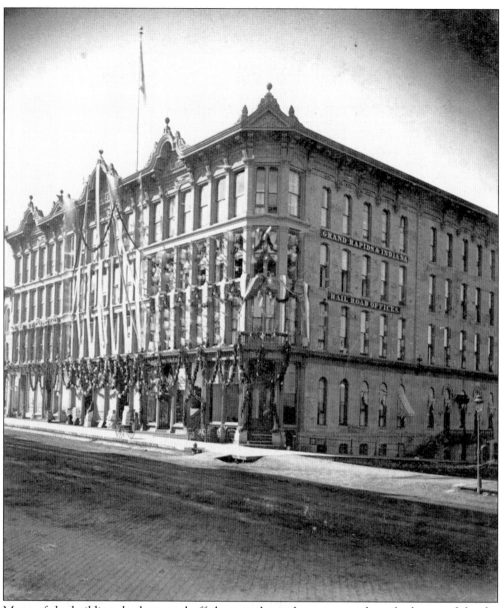

Many of the buildings both on and off the actual parade route were heavily decorated for the occasion, including the Ledyard Building, located on Ottawa Avenue at the corner of Pearl Street. (Horton/GRPL.)

The patriotic decoration of businesses and buildings was not confined to the heart of downtown, as this picture of a structure on Bridge Street, on the west side of the river, attests. (GRPL.)

The Centennial Cabin was a re-creation of the first actual house built in Grand Rapids. Placed in Fulton Street (now Veteran's Memorial) Park for the celebration, it was a careful reconstruction of the cabin of French fur trader Joseph LaFromboise, which was originally erected on the western bank of the Grand River with the consent and assistance of Ottawa chiefs Black Skin and Noonday, perhaps as early as 1806. The exhibit was a very popular feature of the centennial celebration, attracting some 10,000 visitors during the several weeks that it remained in the park. (Horton/GRPL.)

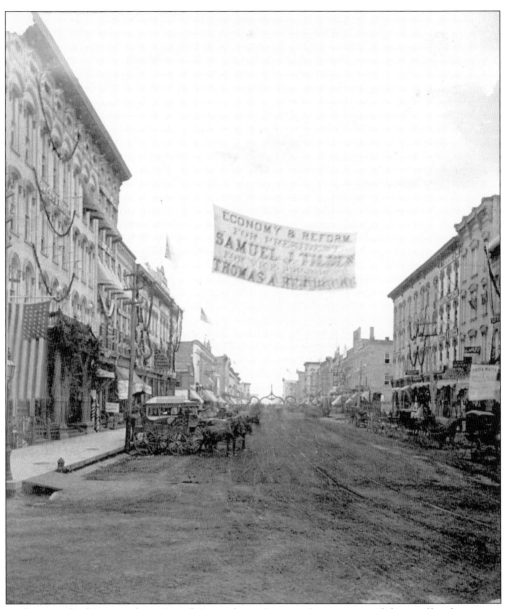

In this view looking north up Canal Street from Campau Square, one of the smaller decorative arches is visible in the center distance. Hung on a cable over the street is a large banner promising "economy and reform" and promoting the candidacy of Samuel F. Tilden in his controversially unsuccessful presidential election bid against Rutherford B. Hayes the following fall. (GRPL.)

BIBLIOGRAPHY

Baxter, Albert. *History of the City of Grand Rapids, Michigan.* Grand Rapids, MI: Munsell and Company, 1891.

Bratt, James D., and Christopher H. Meehan. *Gathered at the River: Grand Rapids, Michigan, and Its People of Faith.* Grand Rapids, MI: Eerdmans, 1993.

Carron, Christian G. *Grand Rapids Furniture: The Story of America's Furniture City.* Grand Rapids, MI: Public Museum of Grand Rapids, 1998.

Centennial Anniversary of American Independence, Celebration at Grand Rapids, Michigan. Grand Rapids, MI: 1876.

Chrysler, Don. *The Story of the Grand River: A Bicentennial History.* Self-published, 1975.

Darrah, William C. *The World of Stereographs.* Nashville, TN: Land Yacht Press, 1977.

Fitch, George E. *Old Grand Rapids.* 1925. Reprint, Gordon Olson and James Van Vulpen, Grand Rapids, MI: Grand Rapids Historical Society, 1986.

Goss, Dwight. *The History of Grand Rapids, Michigan and Its Industries.* Chicago: C. F. Cooper and Company, 1906.

Holmes, Oliver Wendell Sr. "The Stereoscope and the Stereograph." *Atlantic Monthly.* June 1859.

Kuiper, Ronald E. *Crisis on the Grand, The Log Jam of 1883.* Spring Lake, MI: River Road Publications, 1983.

Lydens, Z. Z., ed. *The Story of Grand Rapids: A Narrative of Grand Rapids, Michigan.* Grand Rapids, MI: Kregel, 1966.

Mapes, Lynn G., and Anthony Travis. *Pictorial History of Grand Rapids.* Grand Rapids, MI: Kregel, 1976.

Newhall, Beaumont. *The History of Photography.* New York: Museum of Modern Art, 1982.

Olson, Gordon. *A Free Library for Everyone: The History of the Grand Rapids Public Library.* Grand Rapids, MI: Grand Rapids Public Library, 2003.

Stivers, Julie Christianson. *The Presence of the Past: The Public Museum of Grand Rapids at 150.* Grand Rapids, MI: Public Museum of Grand Rapids, 2004.

Van Vulpen, James. *Grand Rapids Then and Now.* Grand Rapids, MI: Grand Rapids Historical Commission, 1988.

Across America, People are Discovering Something Wonderful. Their Heritage.

Arcadia Publishing is the leading local history publisher in the United States. With more than 3,000 titles in print and hundreds of new titles released every year, Arcadia has extensive specialized experience chronicling the history of communities and celebrating America's hidden stories, bringing to life the people, places, and events from the past. To discover the history of other communities across the nation, please visit:

www.arcadiapublishing.com

Customized search tools allow you to find regional history books about the town where you grew up, the cities where your friends and family live, the town where your parents met, or even that retirement spot you've been dreaming about.